C. Rafa. Morris
1986

Vincent van Gogh Visits New York

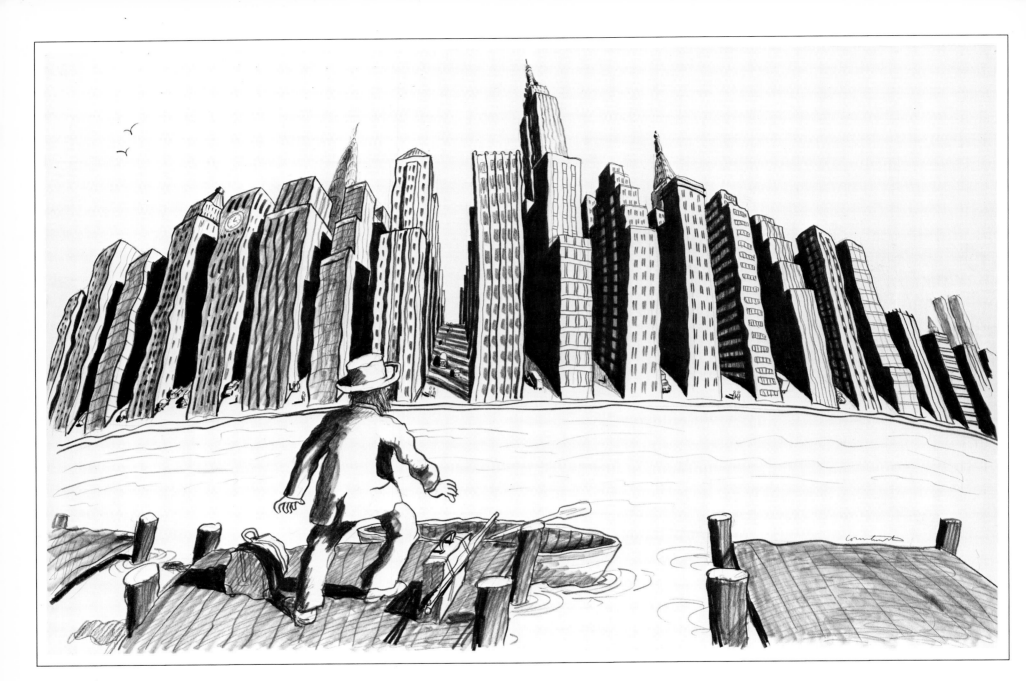

Vincent van Gogh Visits New York

Greg Constantine

Chatto & Windus / The Hogarth Press, London

Published in 1983 by
CHATTO & WINDUS • THE HOGARTH PRESS
40 William IV Street
London WC2N 4DF

Constantine, Greg
 Vincent van gogh visits new york city.
 1. English wit and homour, Pictorial
 I. Title.
 741.5'942 NC1479
 ISBN 0-7011-2732-5

Front cover painting:
"Vincent Bar-Hopping Early Sunday Morning," acrylic on canvas, 1982,
53 x 65 inches. Collection of Norval and Fern Green.

Back cover painting:
"Vincent Defending New Wave Art," acrylic on canvas, 1982,
53 x 65 inches. Collection of the artist.

To Vincent. And all those artists who seem to need protection, understanding, love, and materials.

Acknowledgments

Several individuals have assisted and encouraged me in the preparation
of this book. Gek-Bee Siow organized the list of art references,
Peter Erhard designed the cover, inside graphics, and adapted
the captions and title from Vincent's own handwriting.
Robert Scudellari demonstrated his patience by walking
with me the entire length of the publishing path.

Vincent van Gogh Visits New York

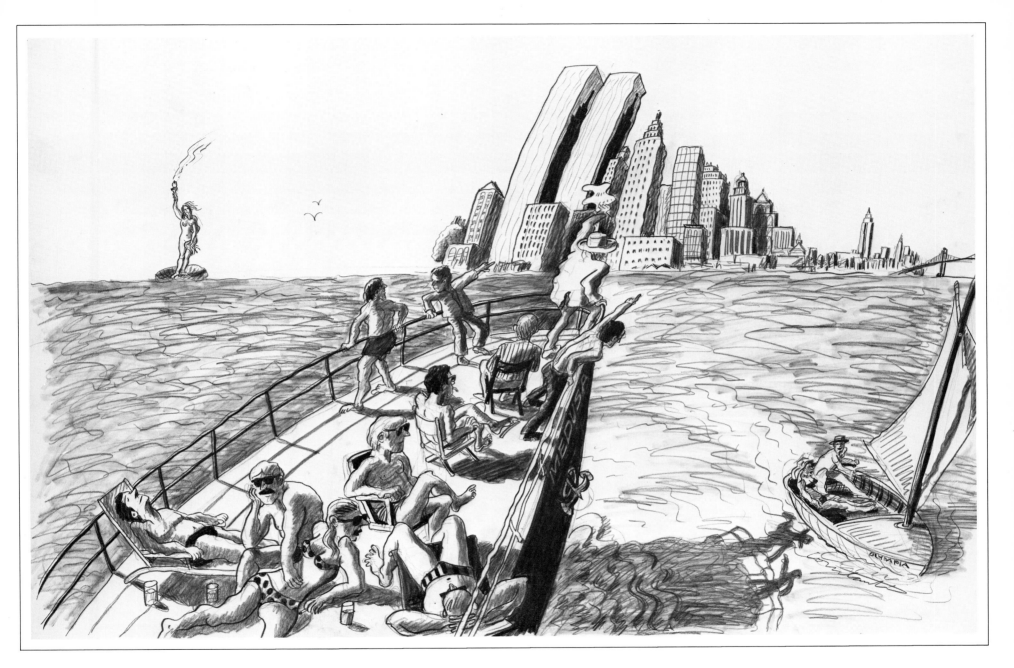

Sighting Manhattan

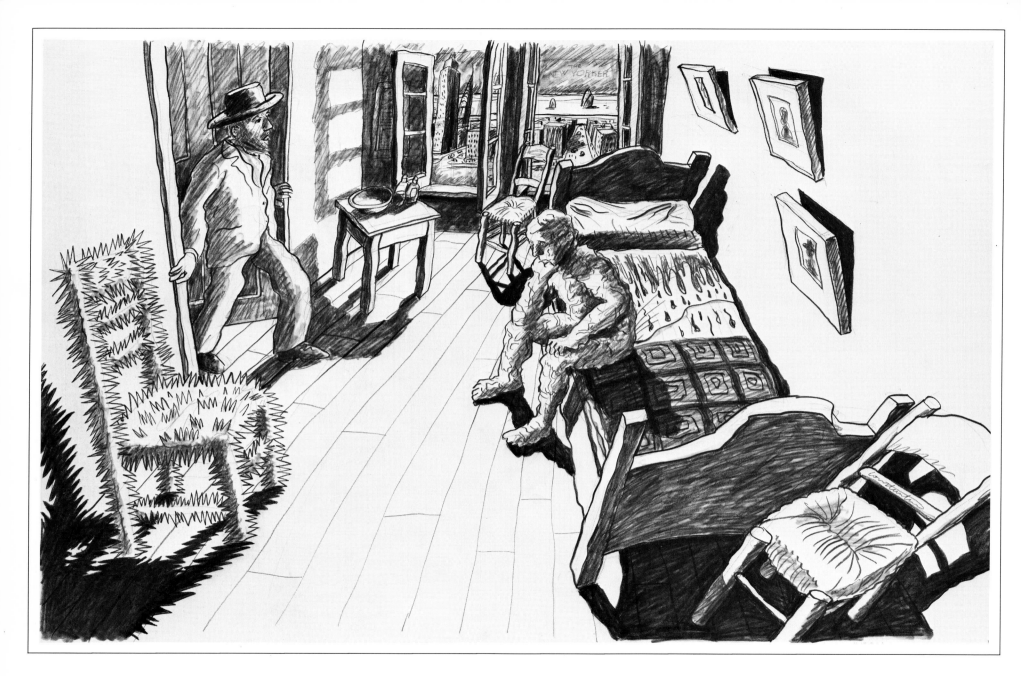

Finding a bedroom to rent

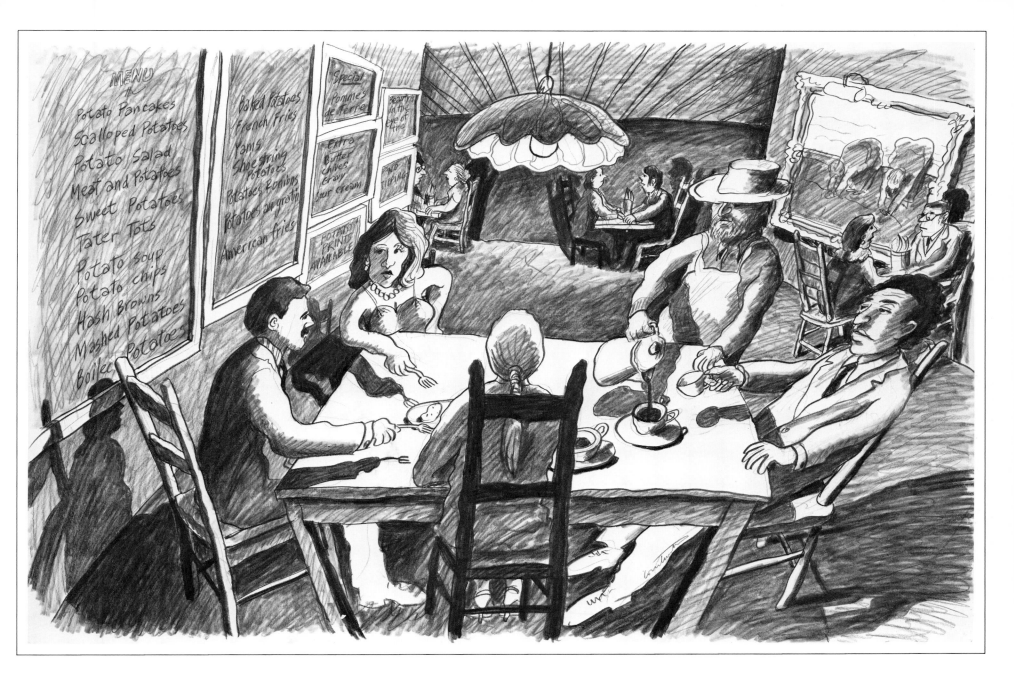

Waiting on tables in the Village

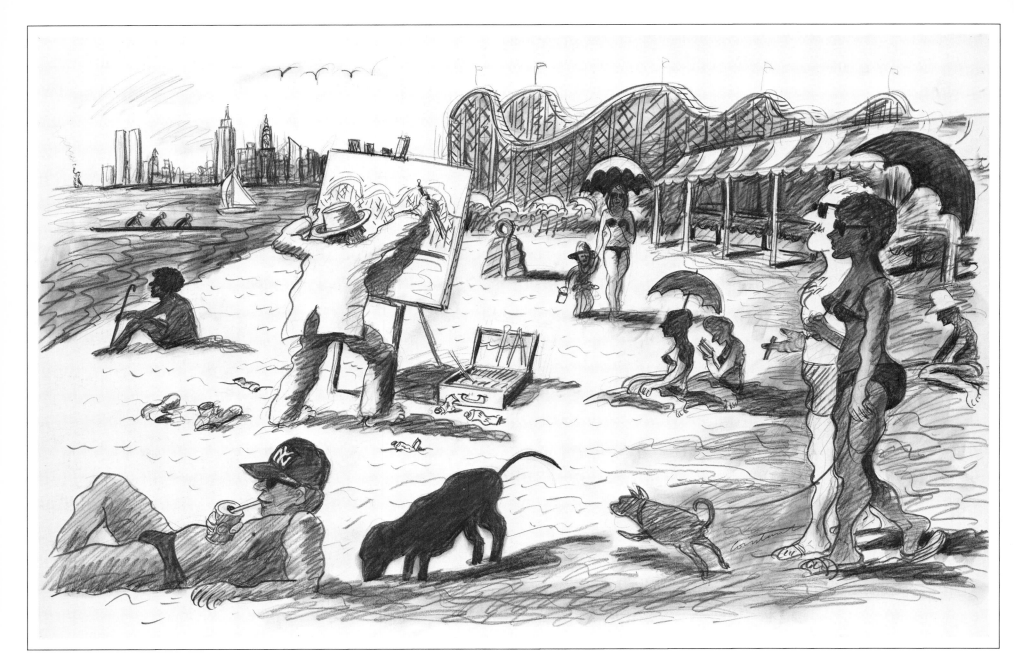

Painting Coney Island on a Sunday afternoon

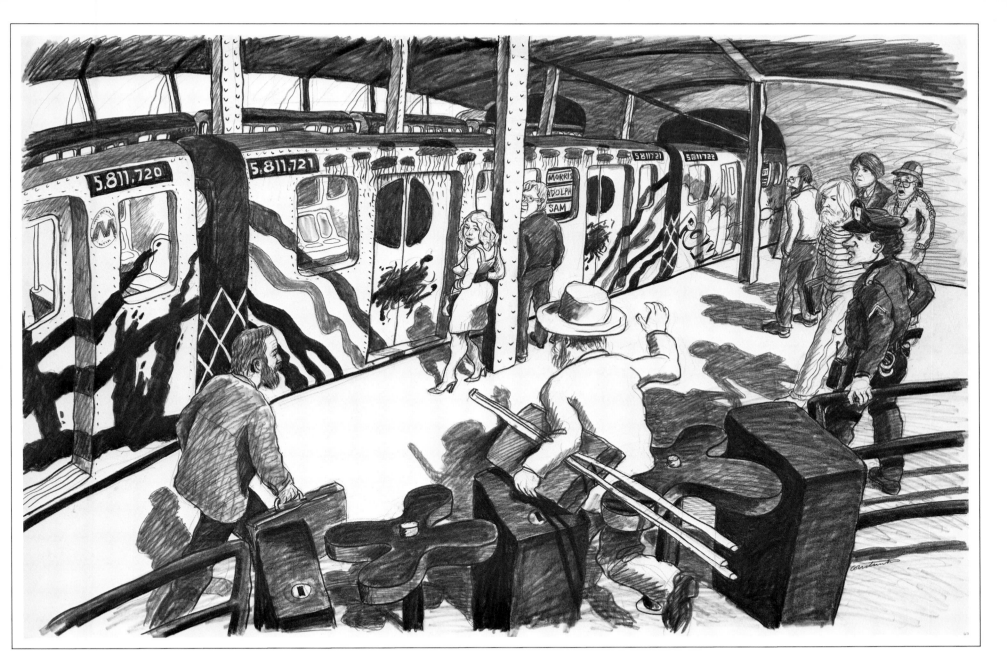

Getting stuck in the subway

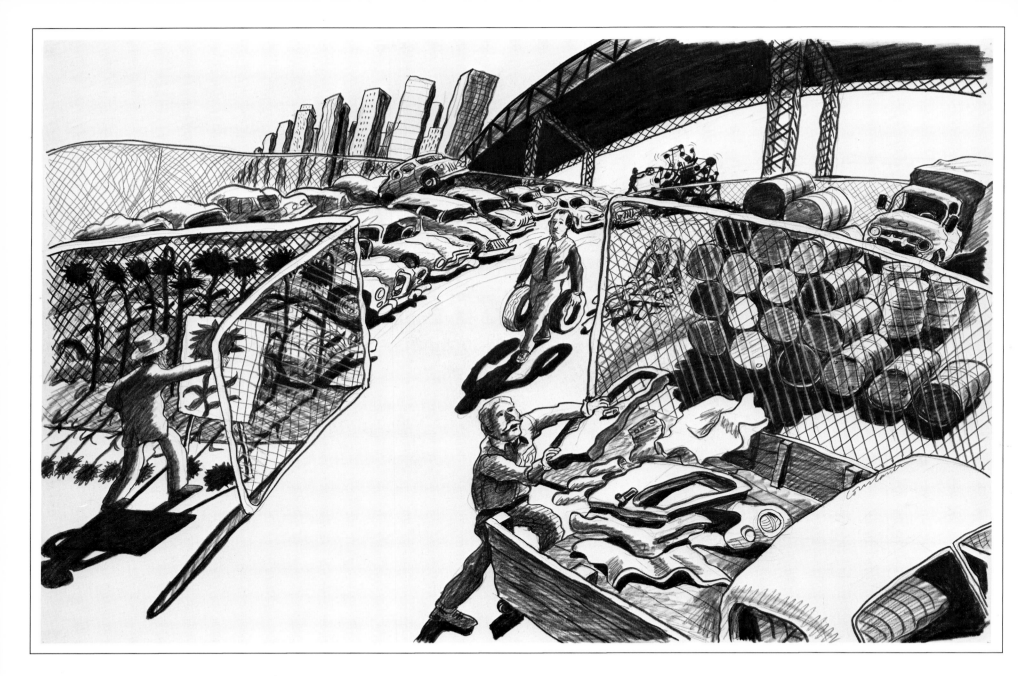

Painting sunflowers in Queens

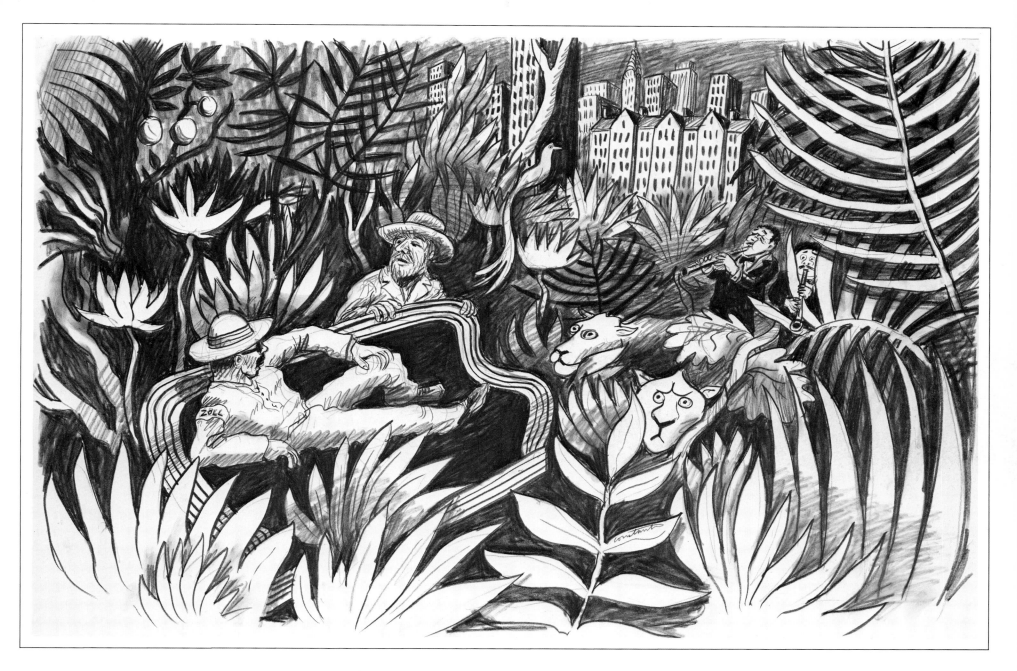

Discovering Rousseau in Central Park

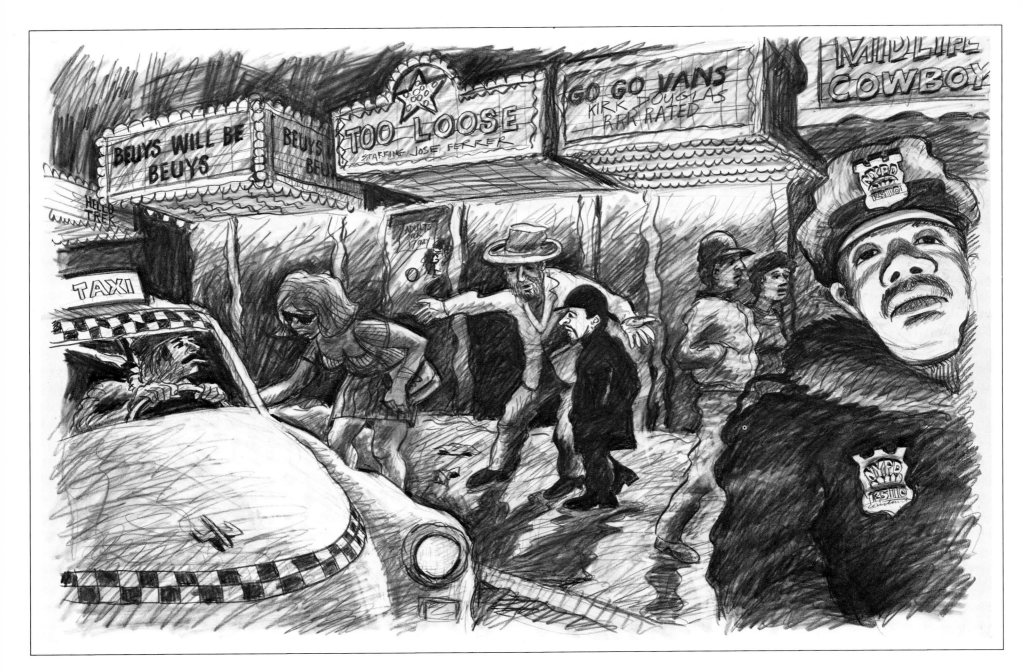

Meeting Lautrec on Forty-second Street

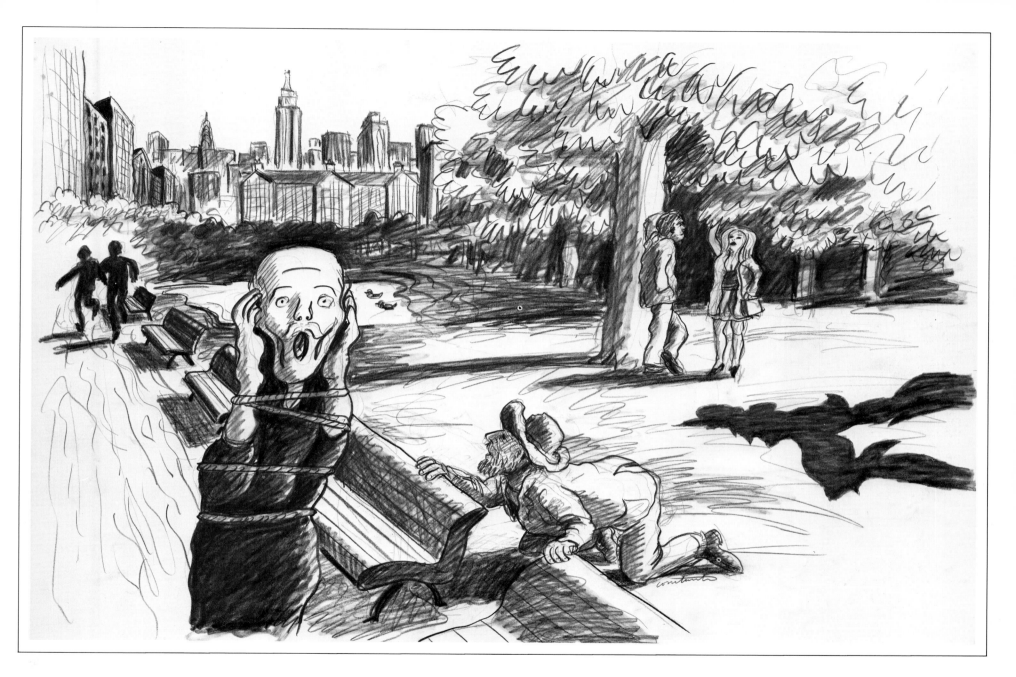

Getting mugged with Munch in Central Park

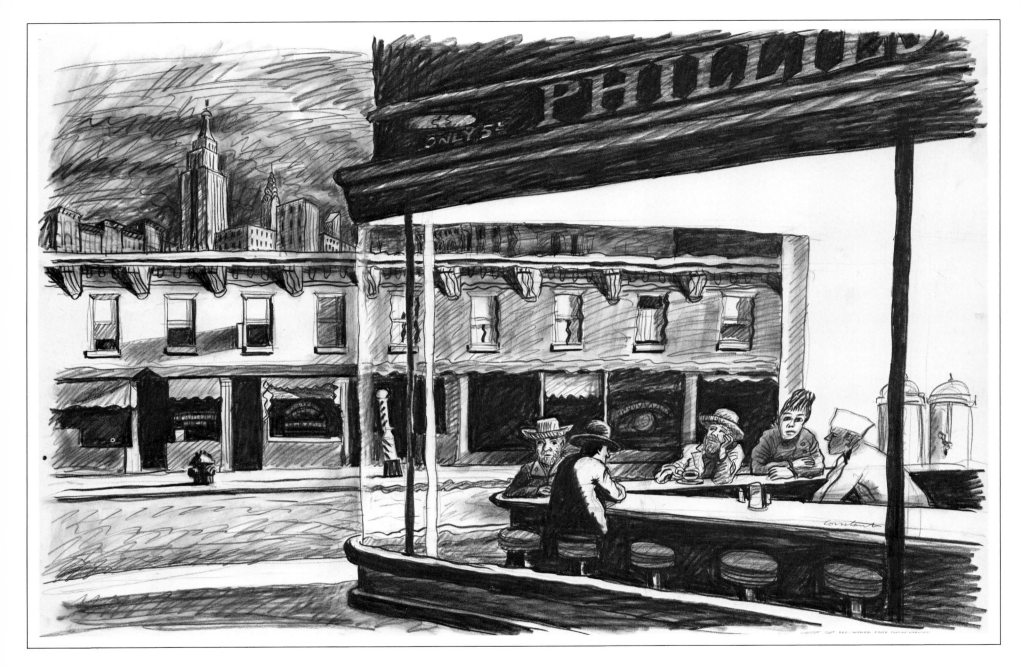

Bar-hopping early Sunday morning

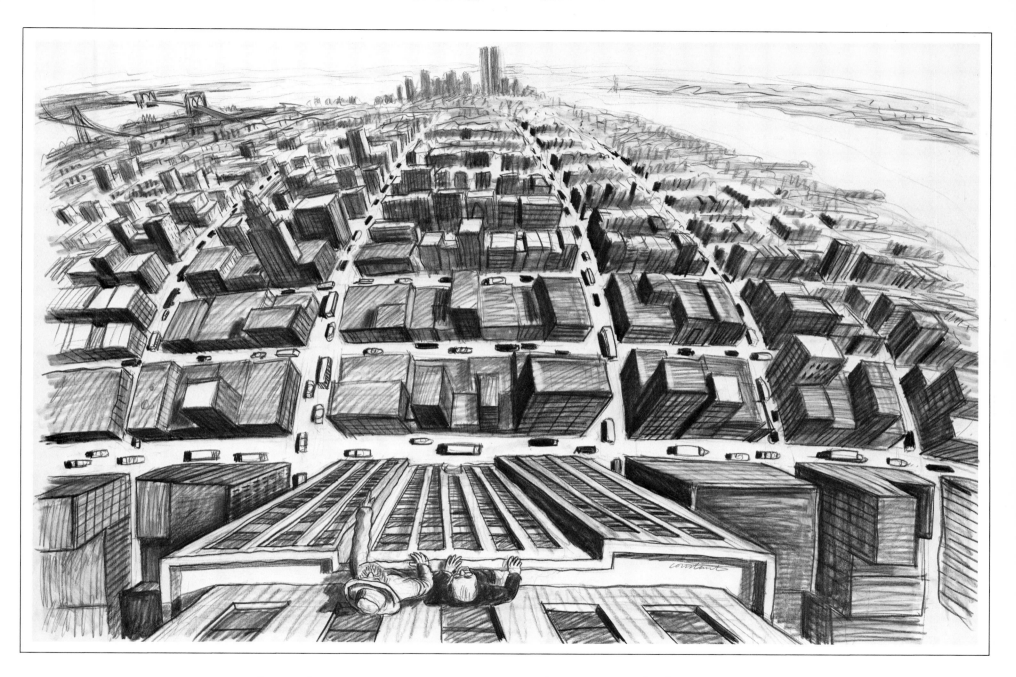

Vincent and Mondrian boogeying on the Empire State Building

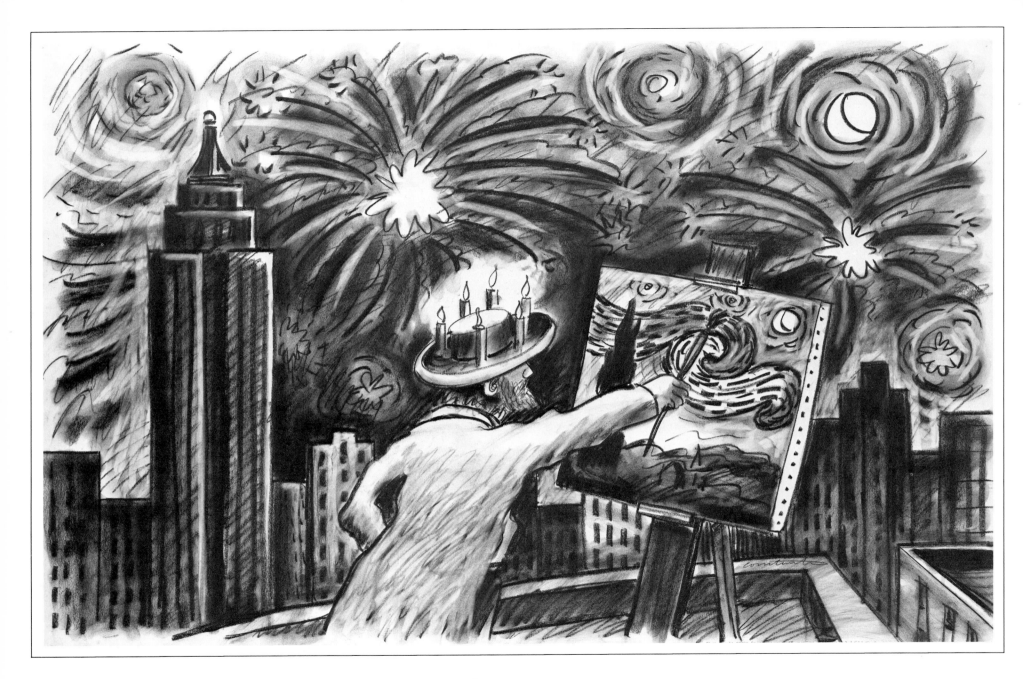

Painting Fourth of July fireworks over Manhattan

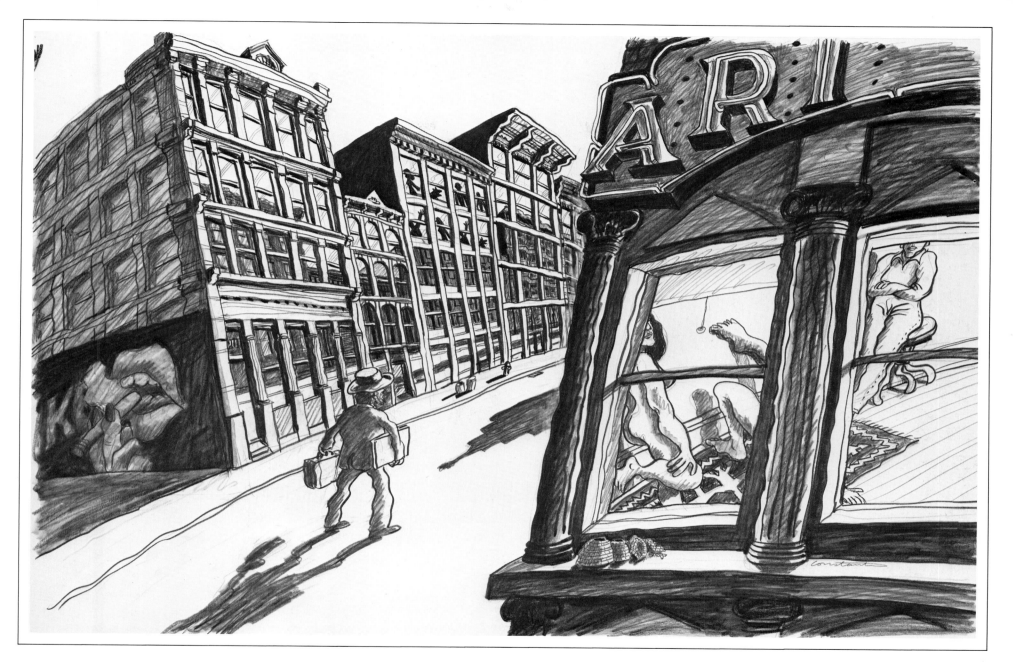

Arriving in SoHo

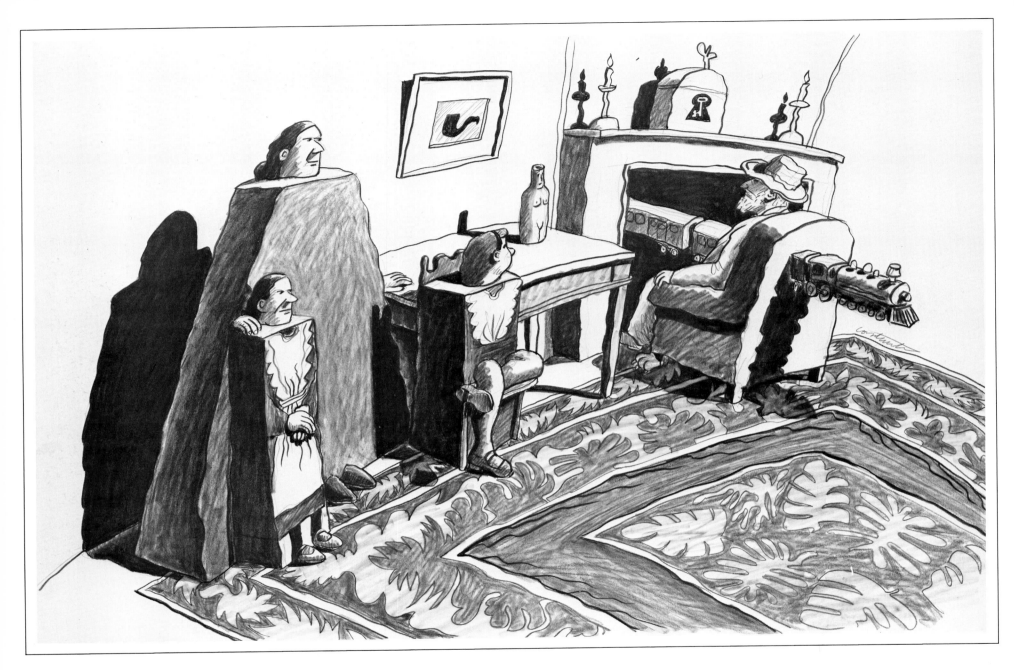

The Bellelli sisters' ma greets Vincent

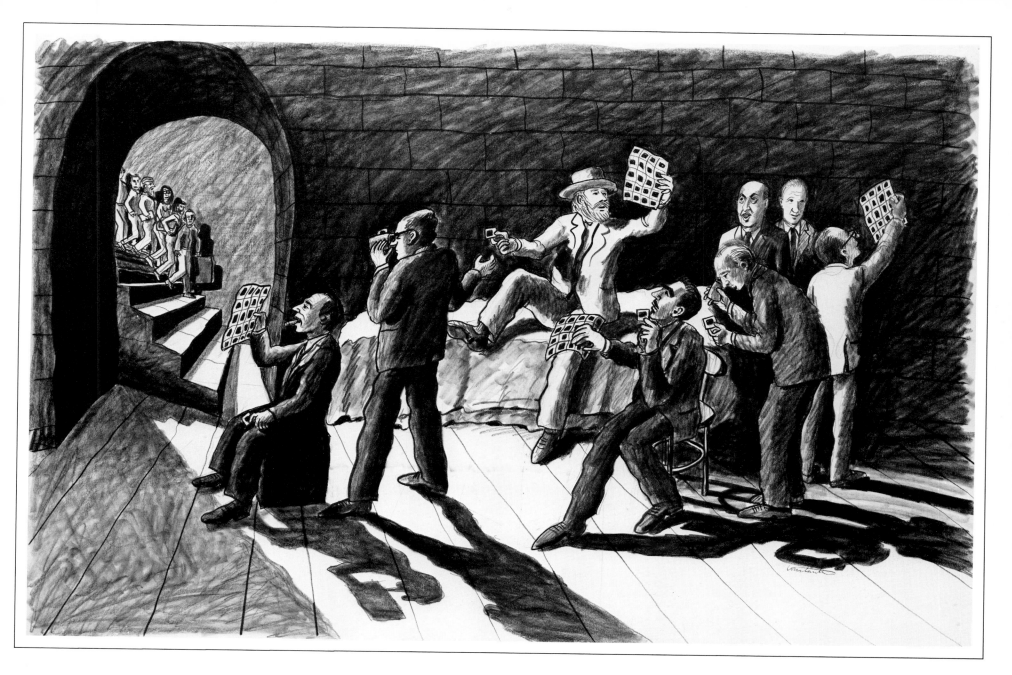

Showing slides of work to New York dealers and critics

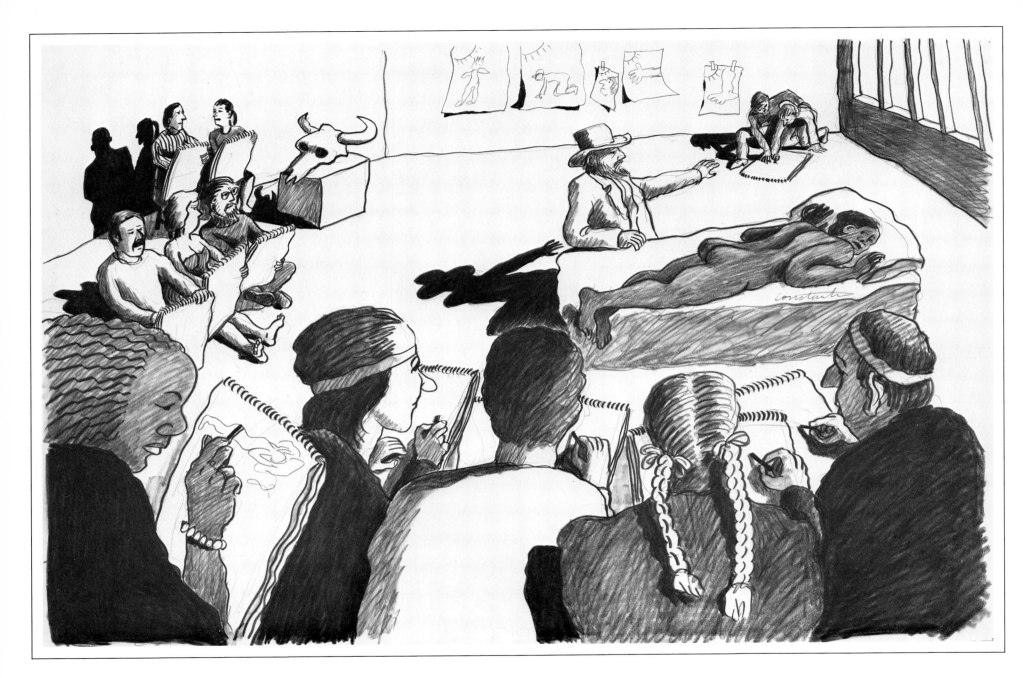

Guest artist at Cooper Union

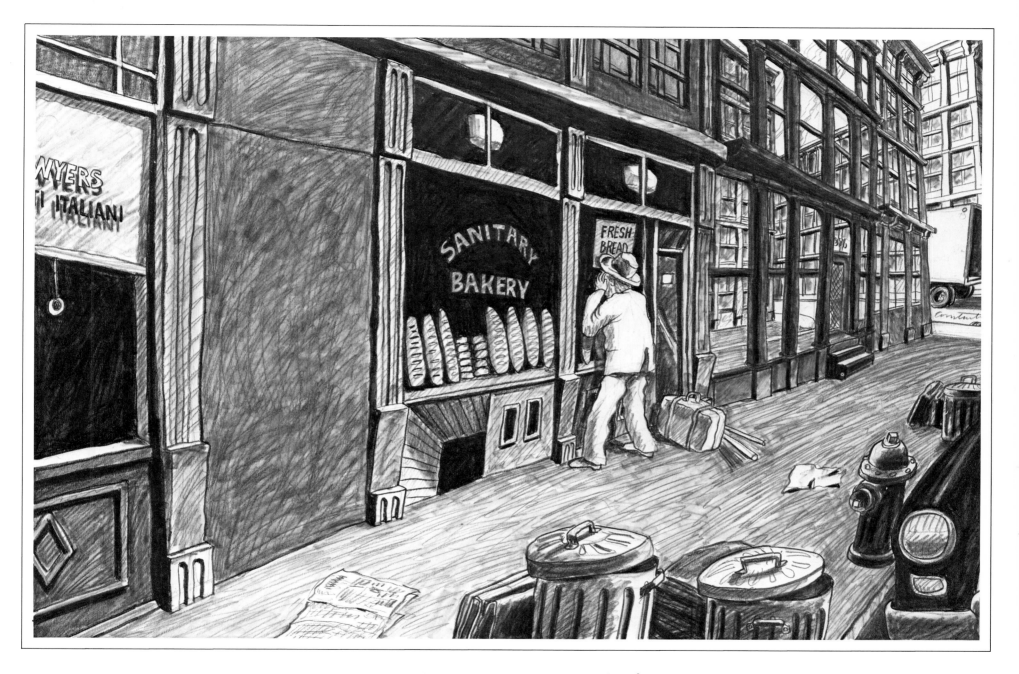

Peering into Haas' Bakery in Little Italy

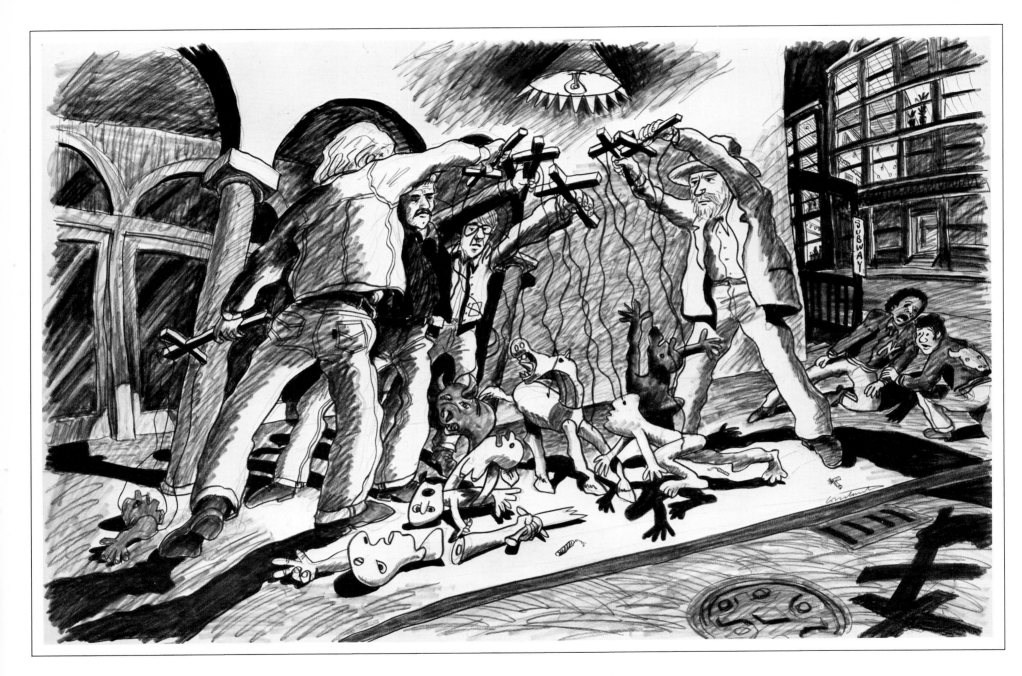

Operating a profane puppet theater

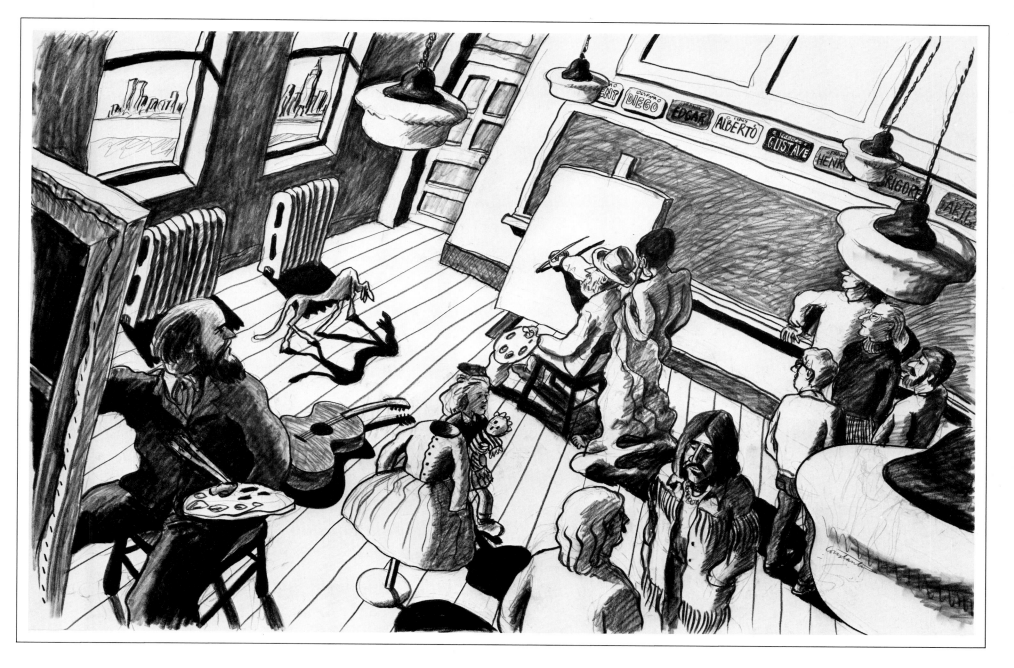

P.S. 1 studio

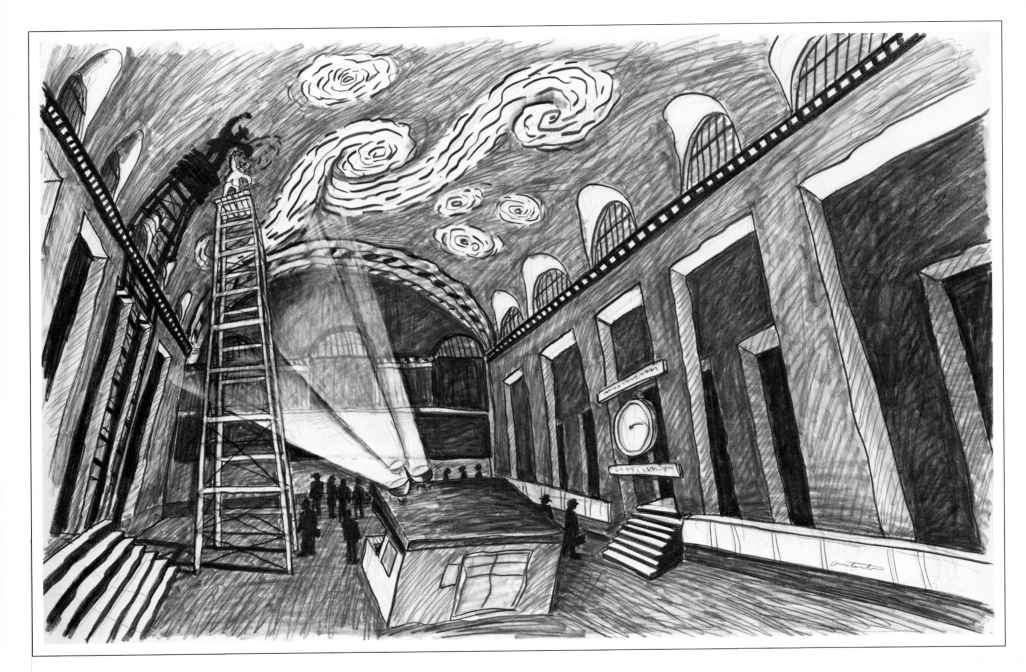

Painting the Grand Central Sistine ceiling

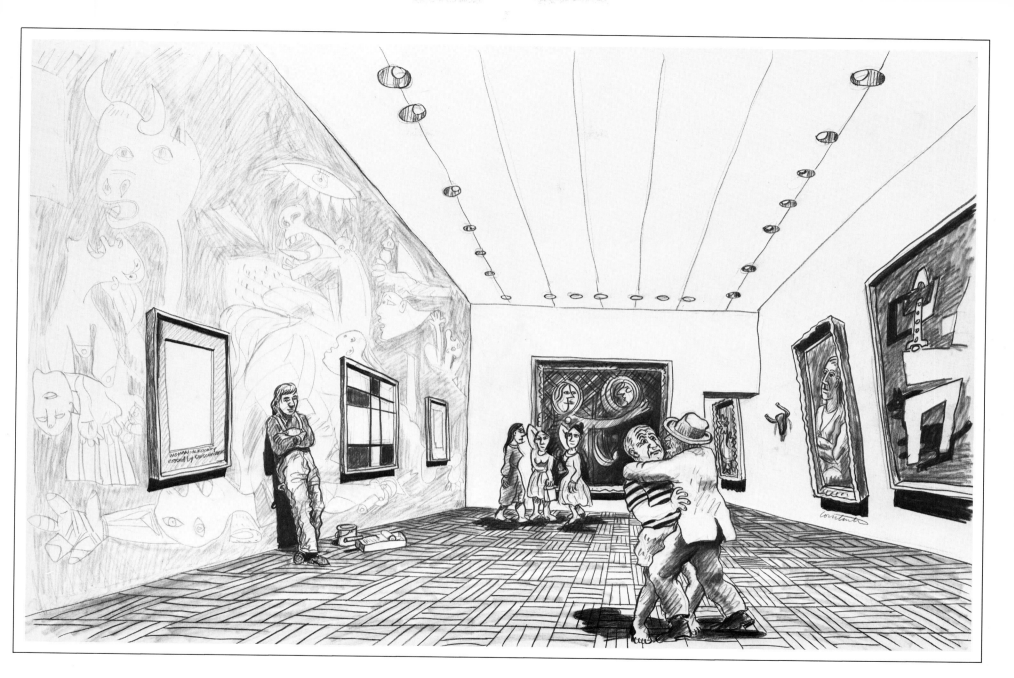

Going to see Picasso at the Museum of Modern Art

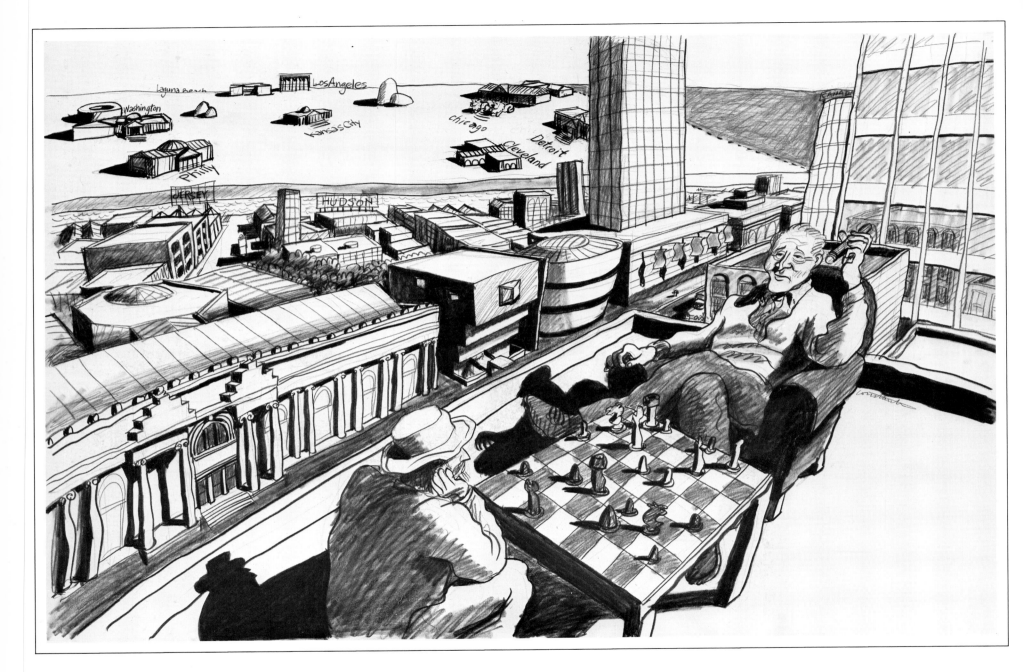

Vincent about to checkmate Duchamp above "museum row"

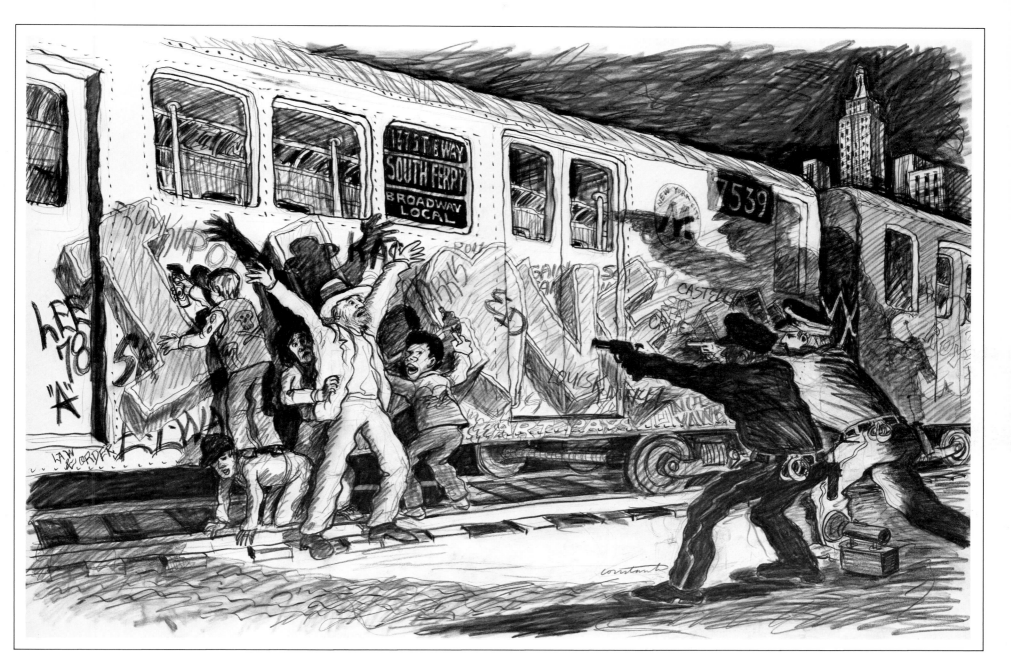

Defending New Wave Art

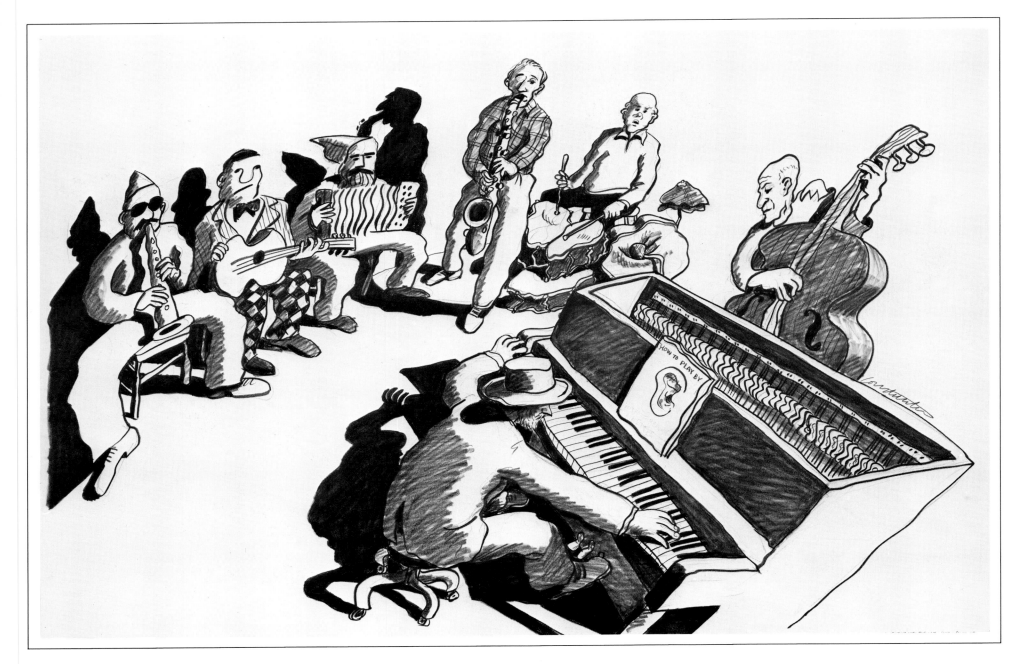

Jamming it up with the Arts Jazz Septet

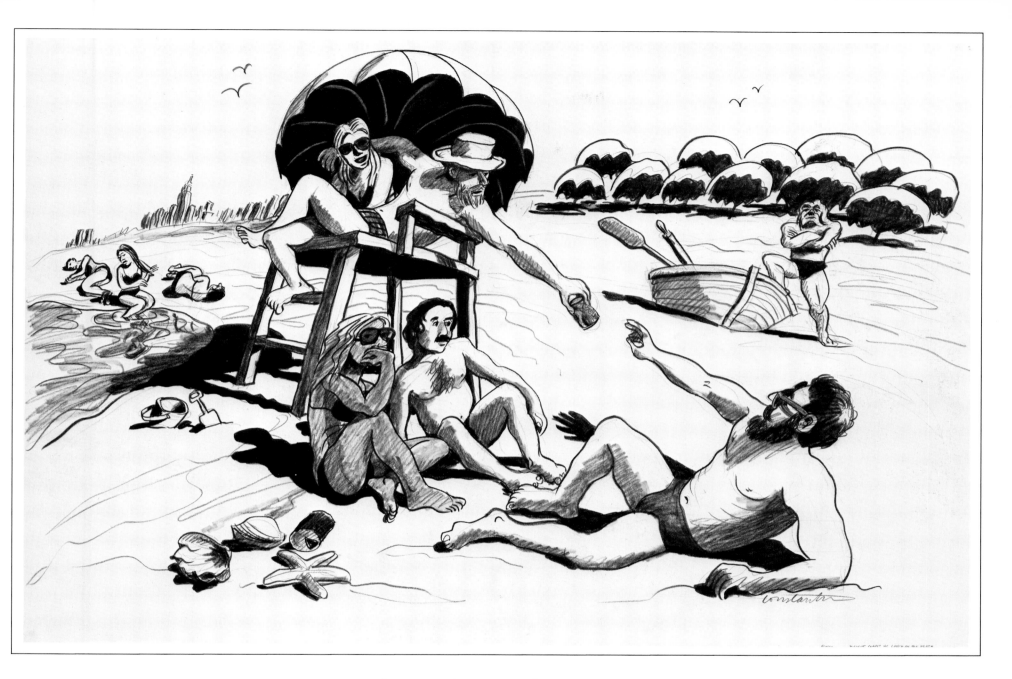

Sharing lunch on the beach

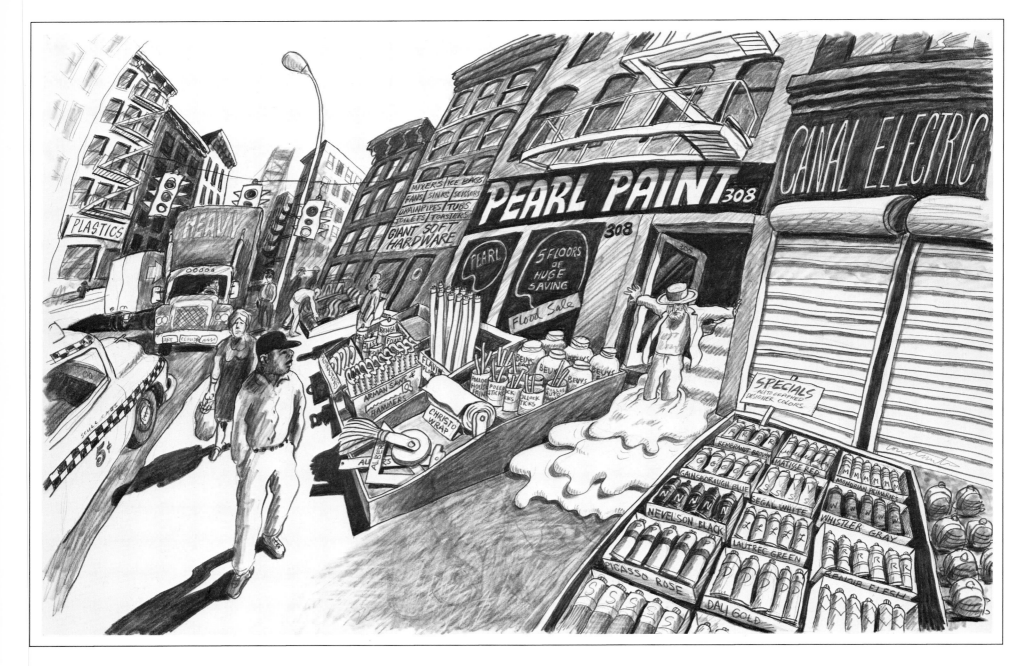

Sidewalk sale at Pearl Paint

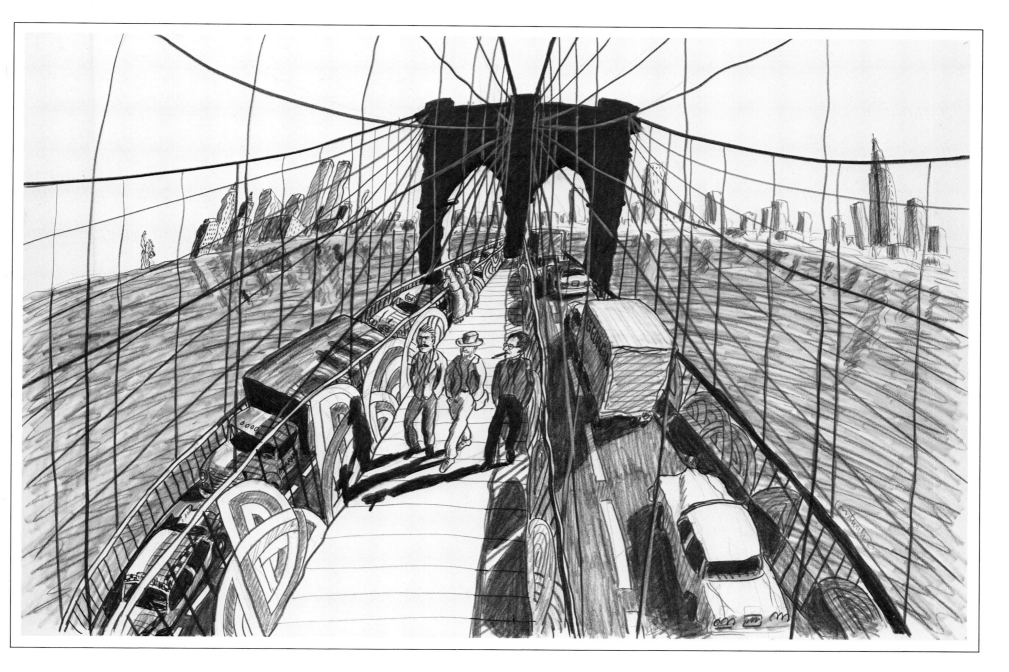

Strolling on the Brooklyn Bridge with Joe and Frank Stella

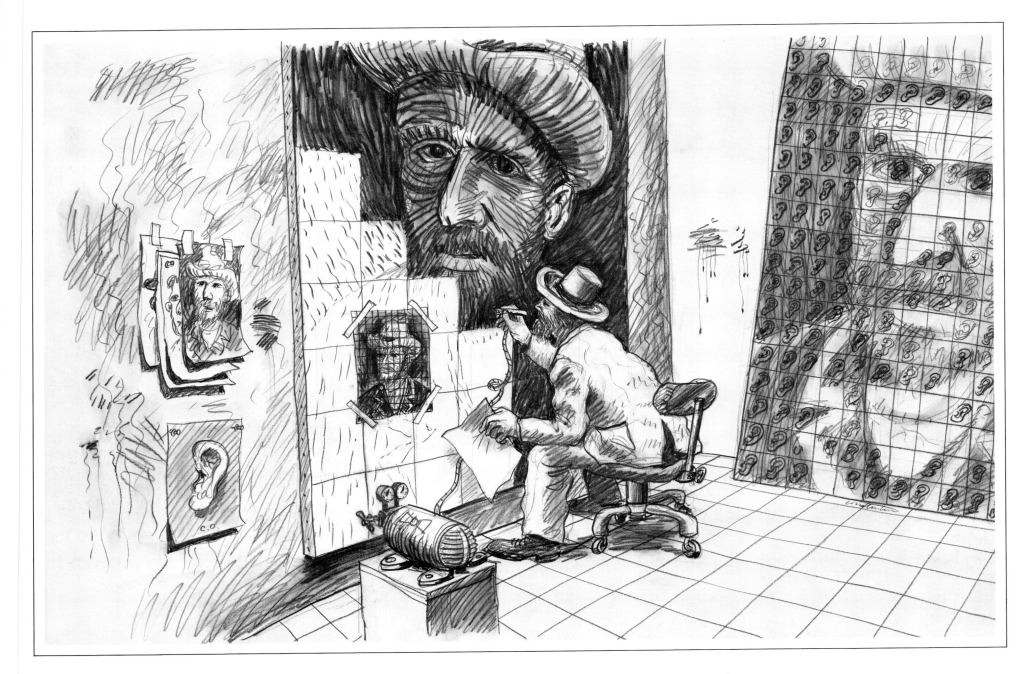

Using Chuck Close's studio to paint a self-portrait

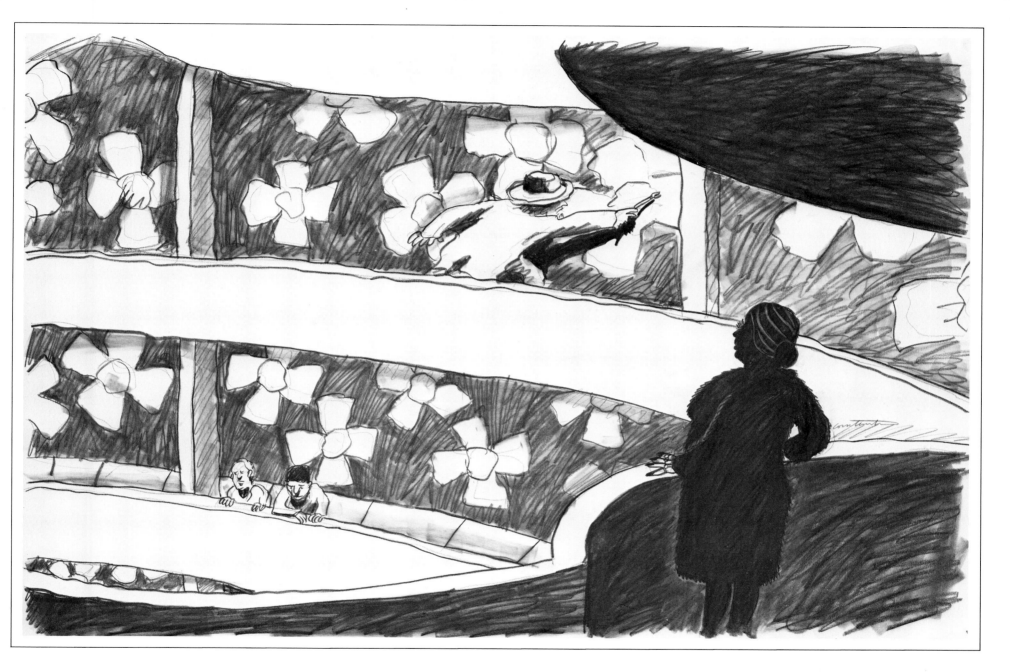

Painting Warhol daisies in the Guggenheim

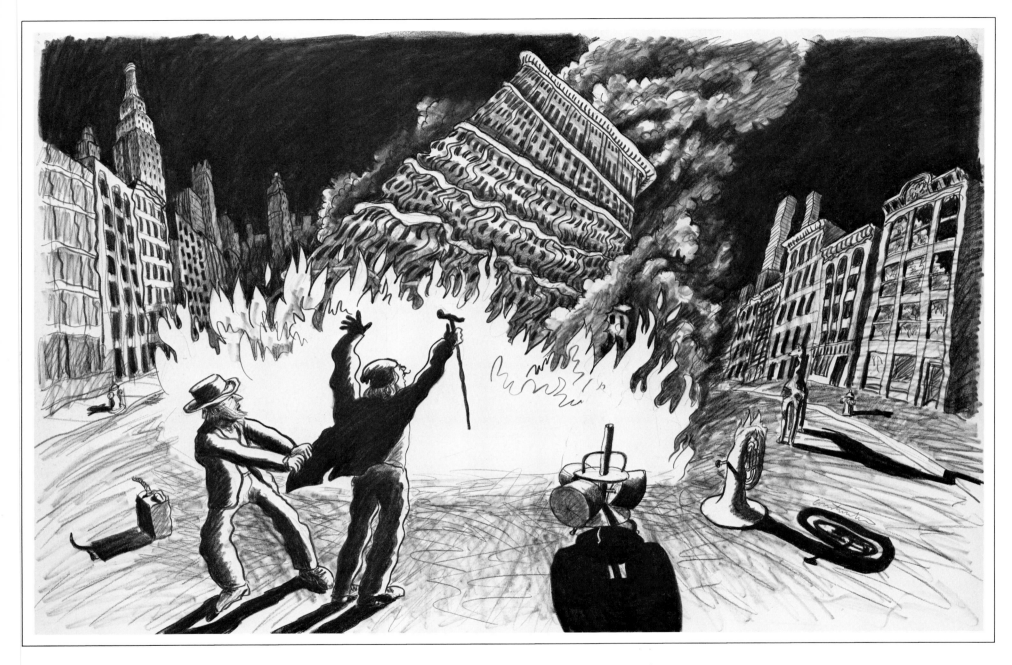

Dali attempting to melt the Flatiron Building

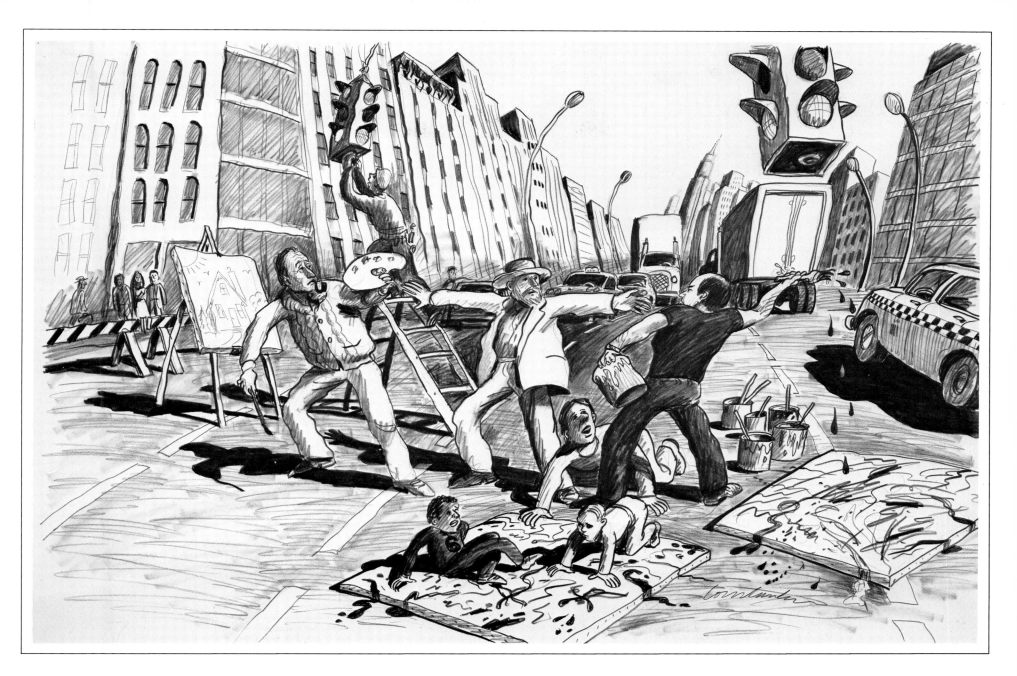

Quelling the conflict between the Realists and Abstractionists

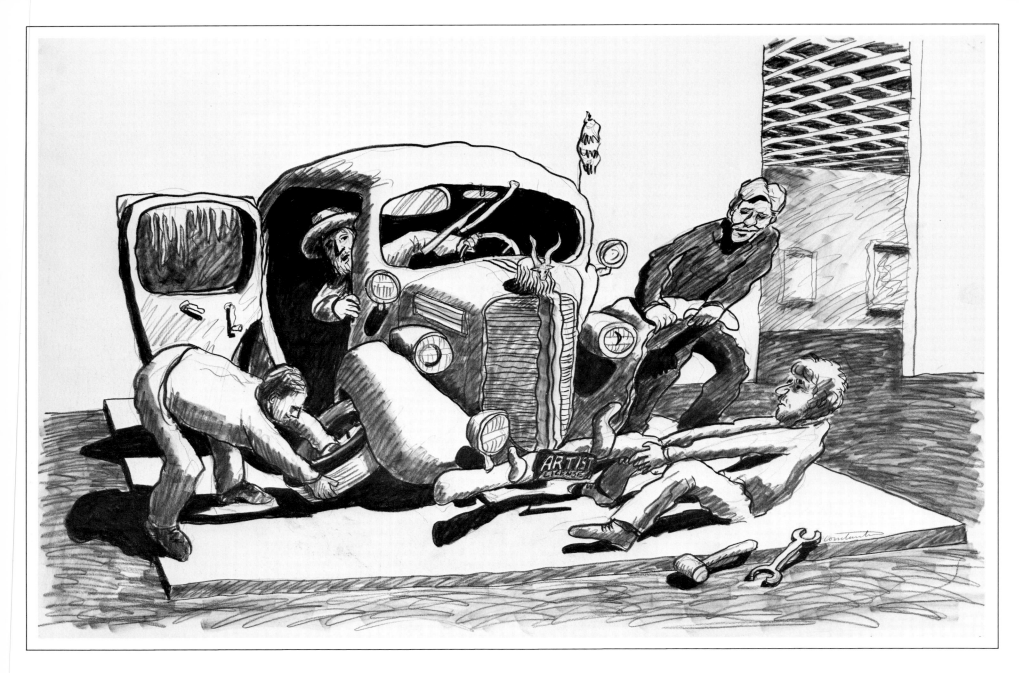

Vincent visiting Kienholz's Car at the Whitney

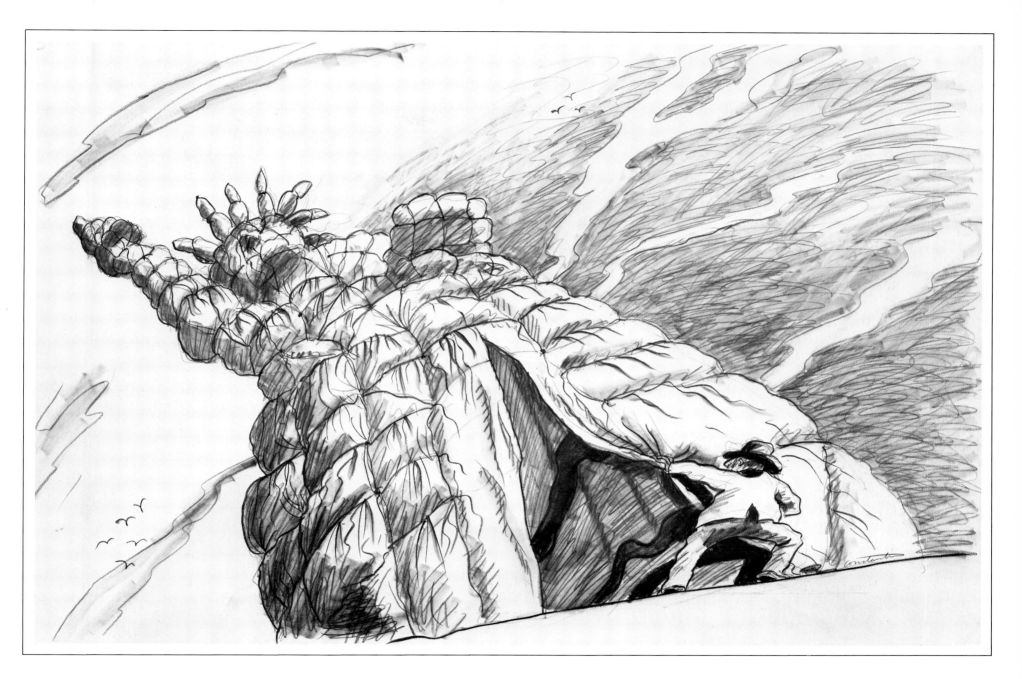

Unwrapping the Statue of Liberty

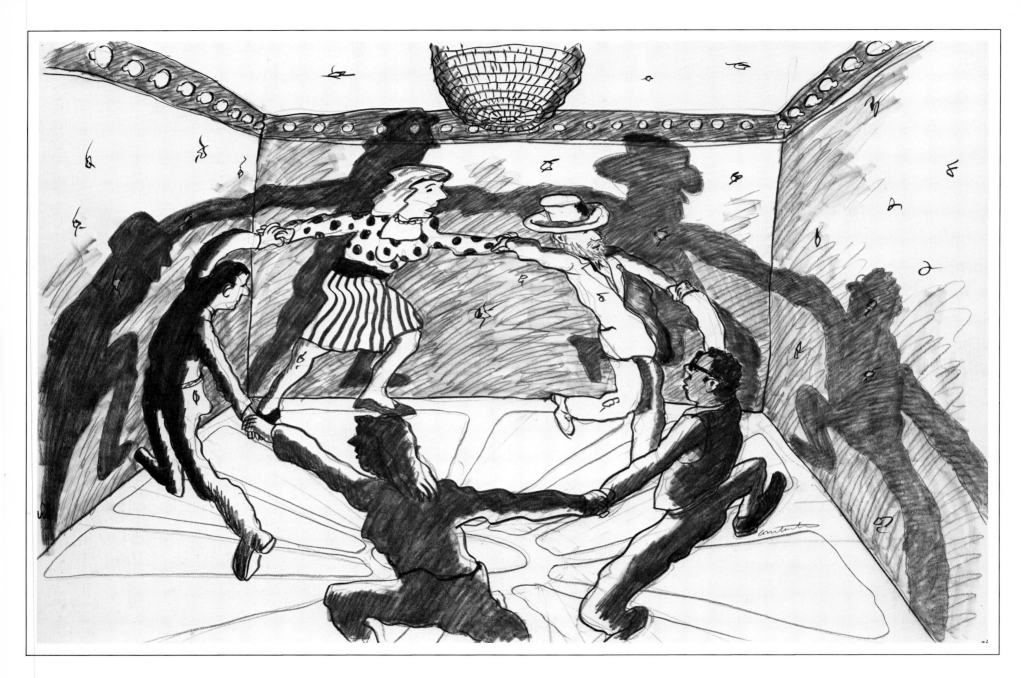

Van Gogh going at Studio 54

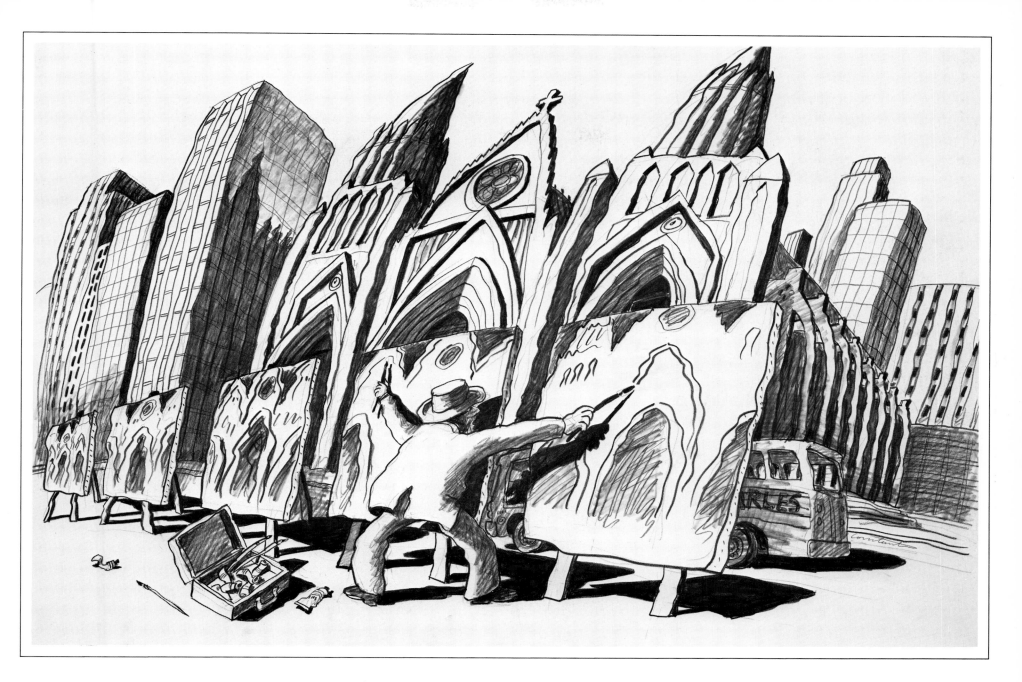

Painting a series of St. Patrick's Cathedrals

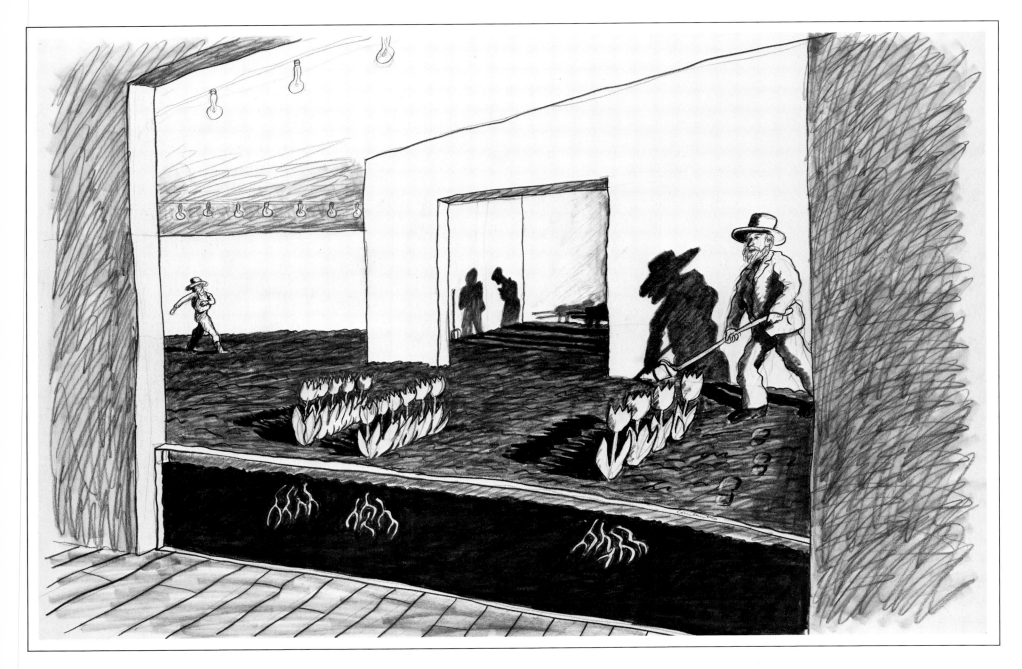

Planting tulips in De Maria's Earth Room

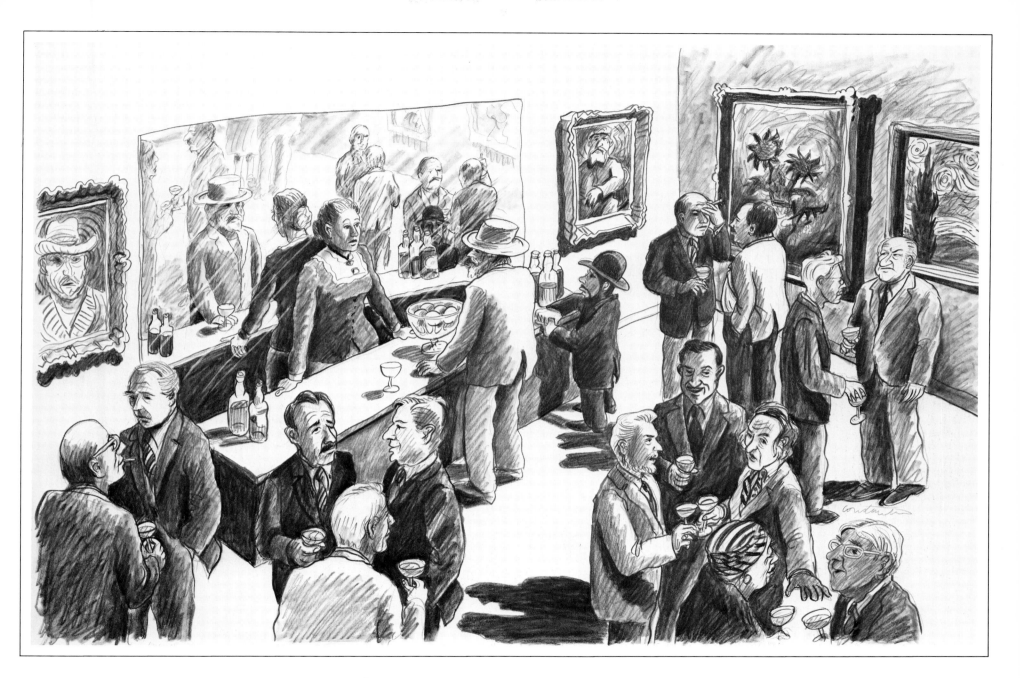

At the bar during his opening reception

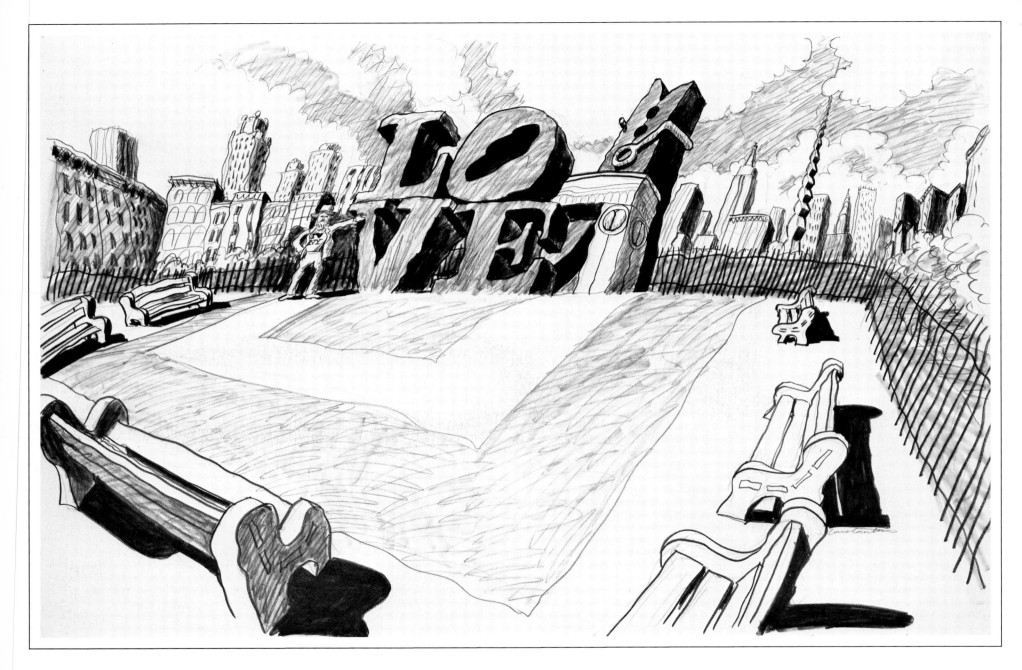

Vincent in Washington Albers' Square

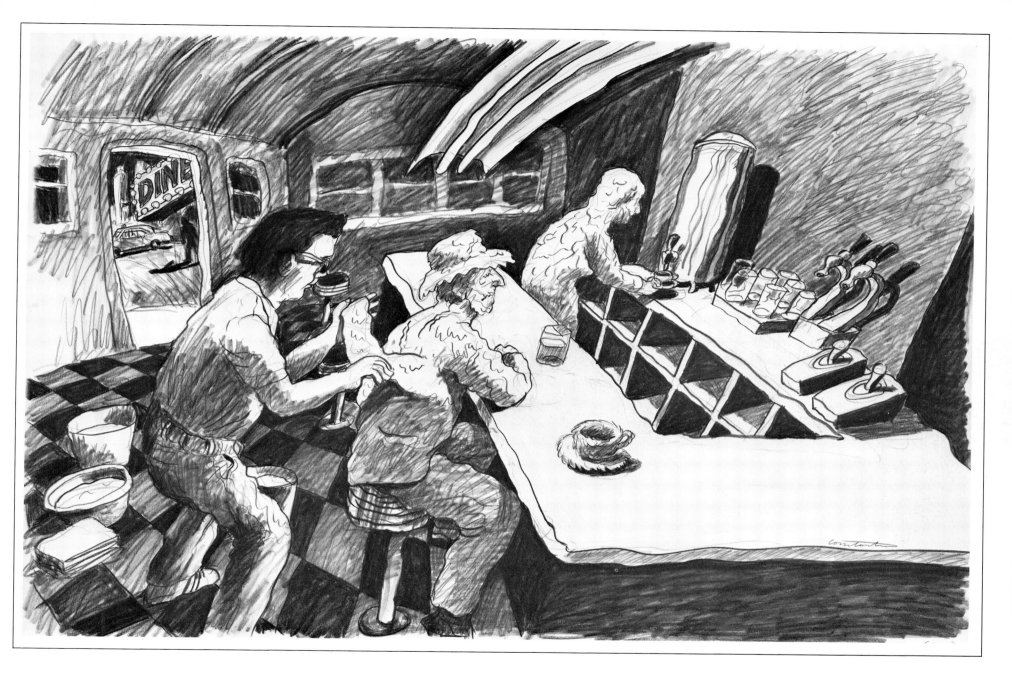

Getting plastered at George Segal's Diner

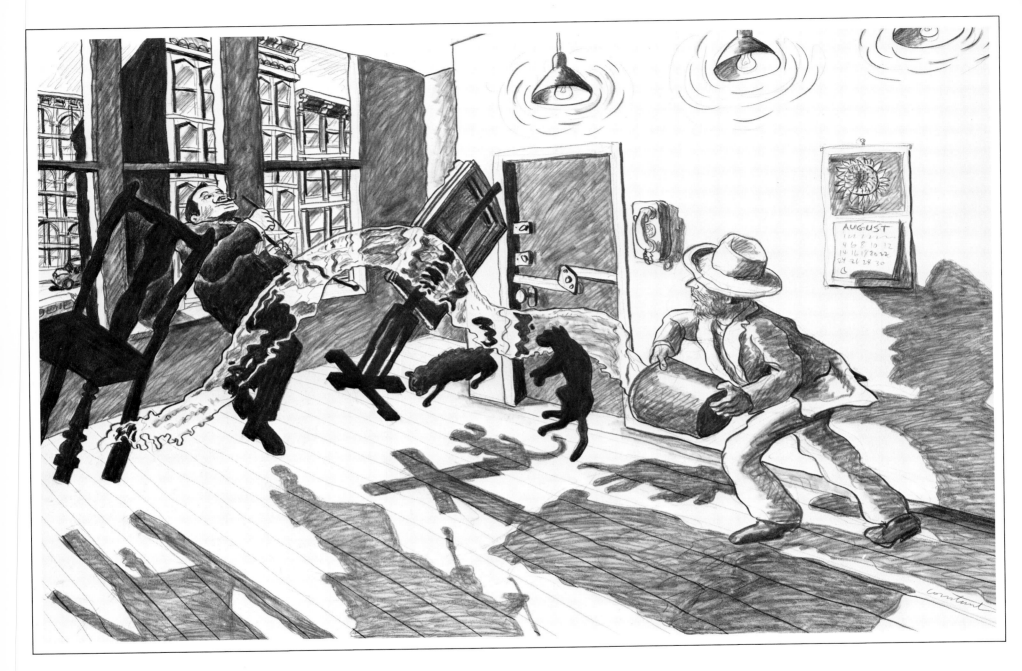

Throwing Dali out of his loft

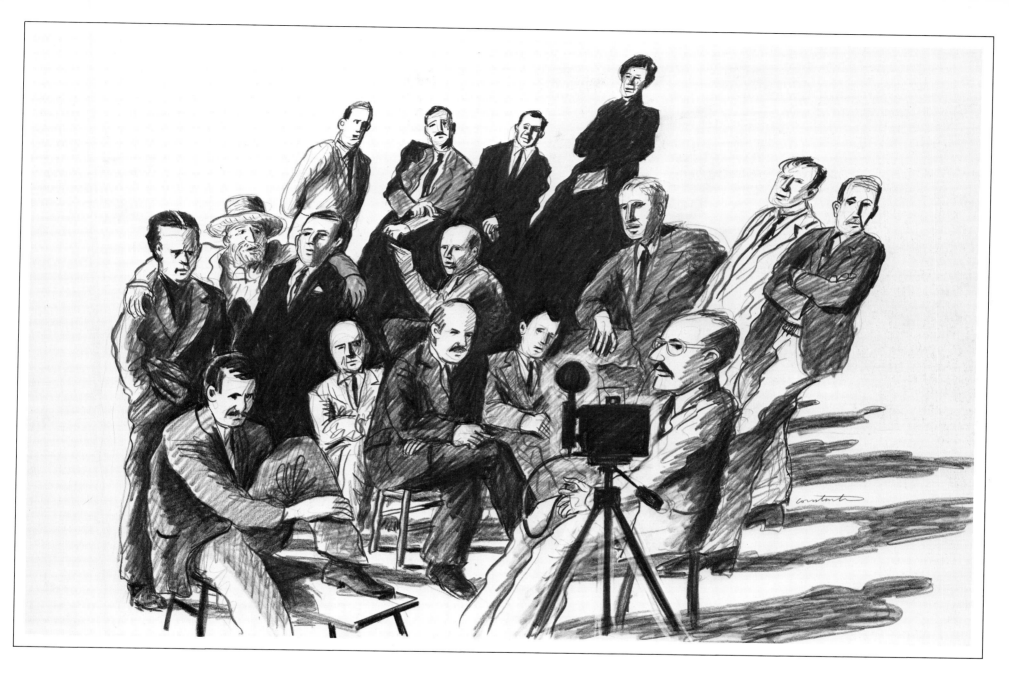

Joining the "Irascibles"

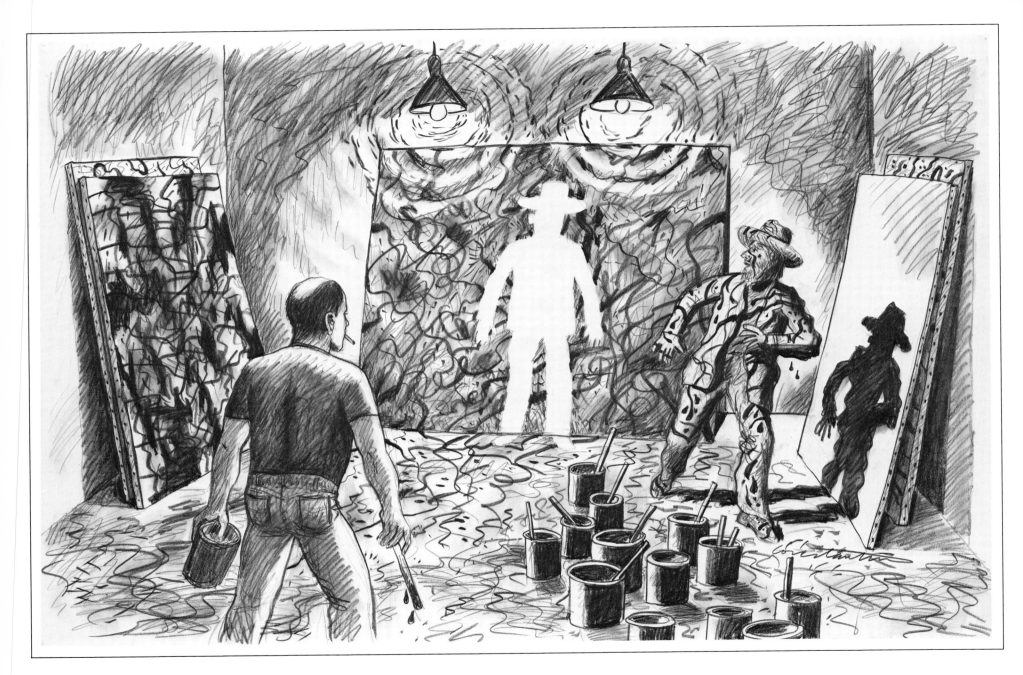

Pollock painting Vincent's portrait

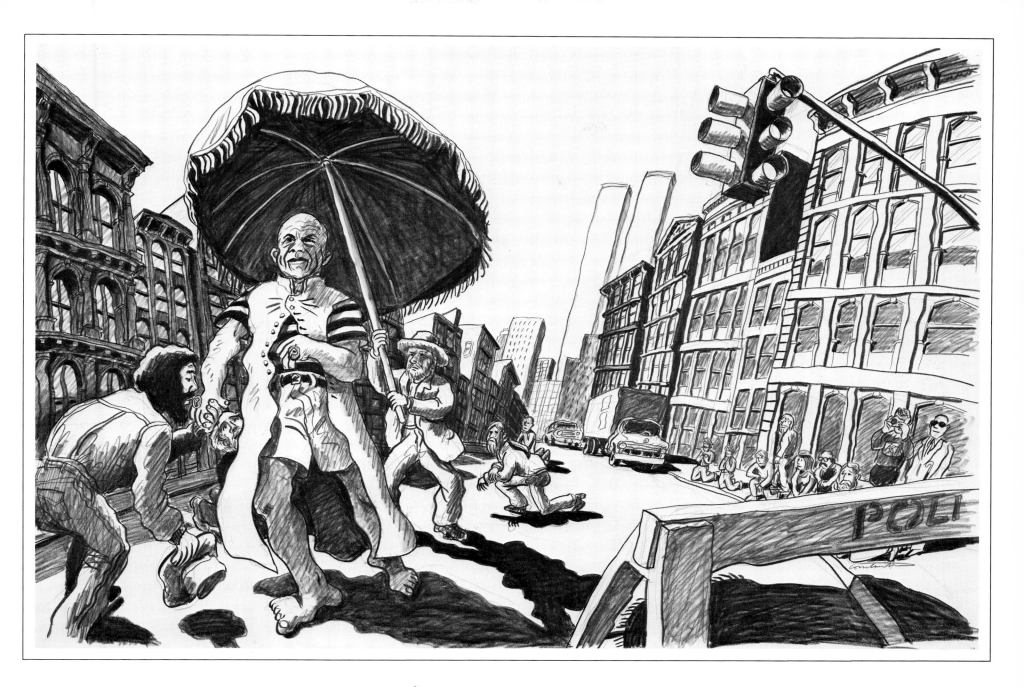

Serving Pope Picasso on West Broadway

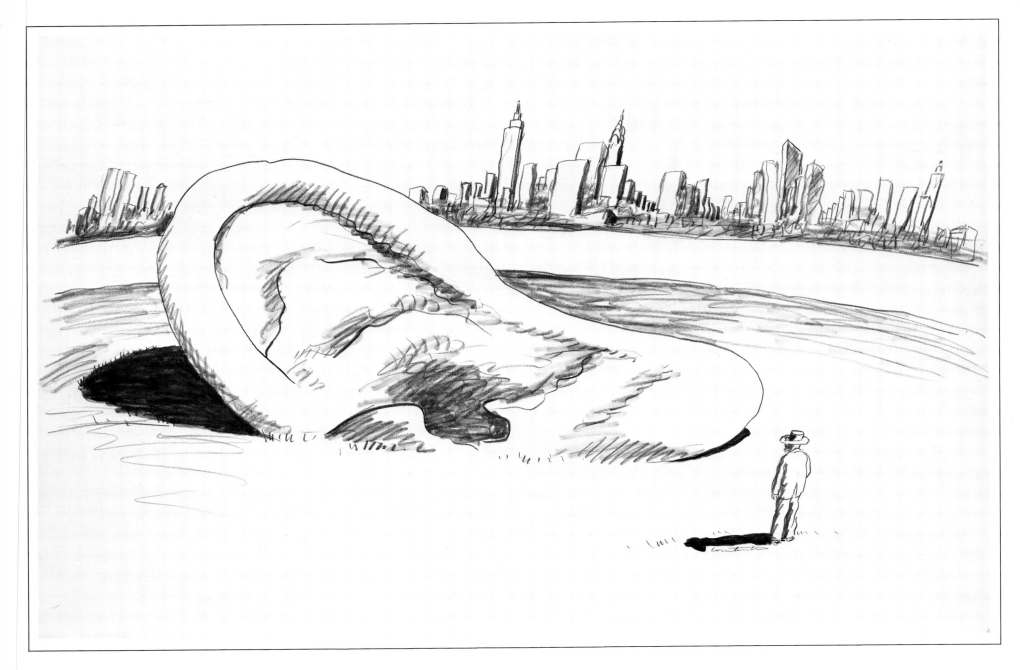

Contemplating Oldenburg's Colossal Ear

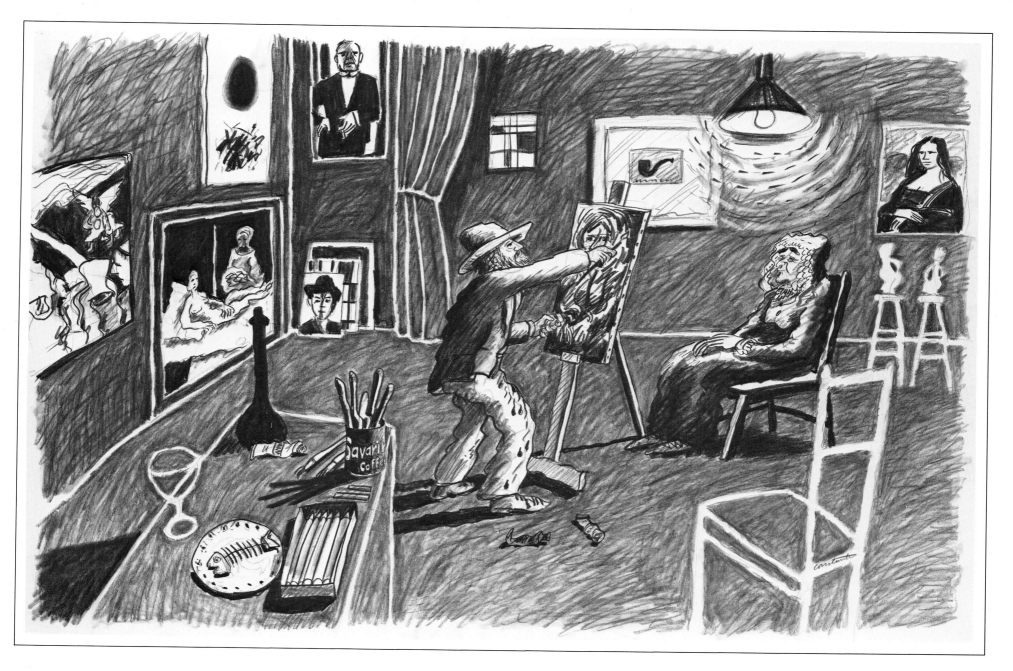

Painting a portrait of his mother

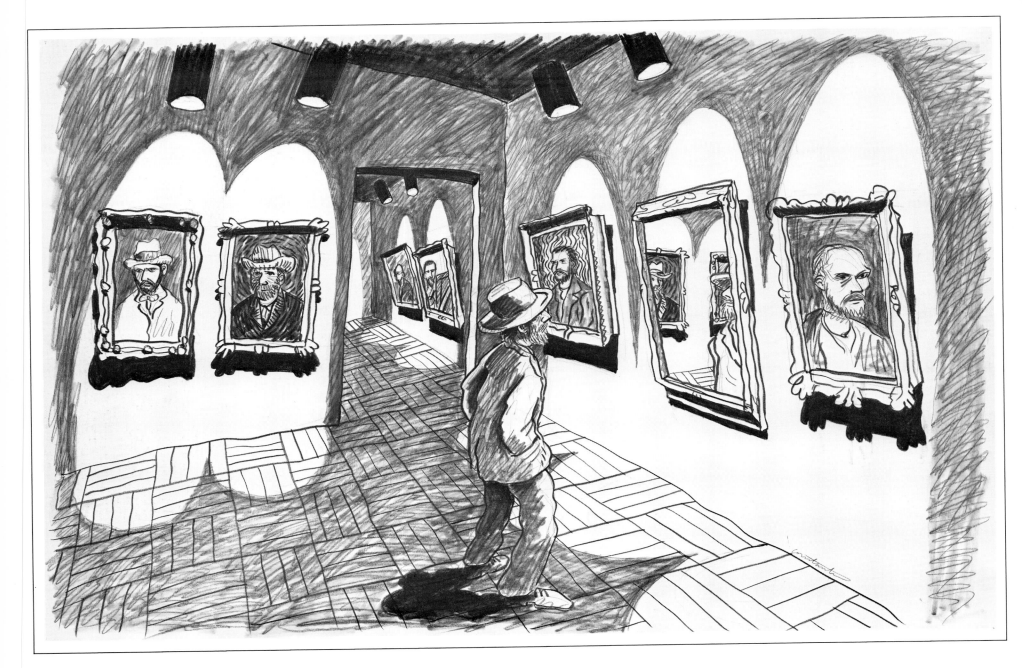

Attending an exhibit of self-portraits at the Metropolitan

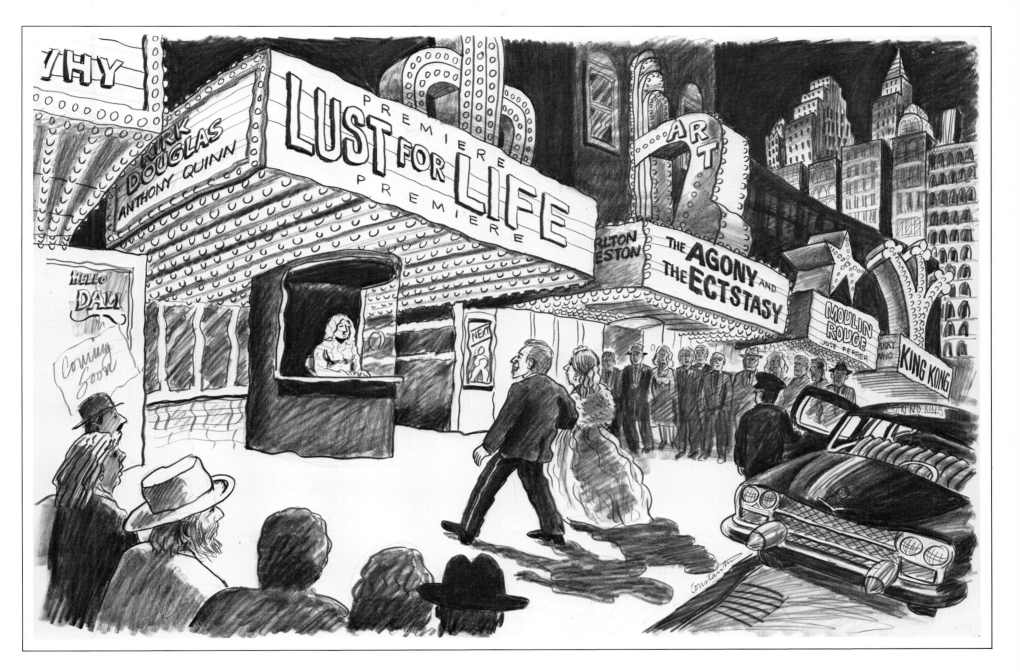

Seeing Kirk Douglas at the premiere of <u>Lust for Life</u>

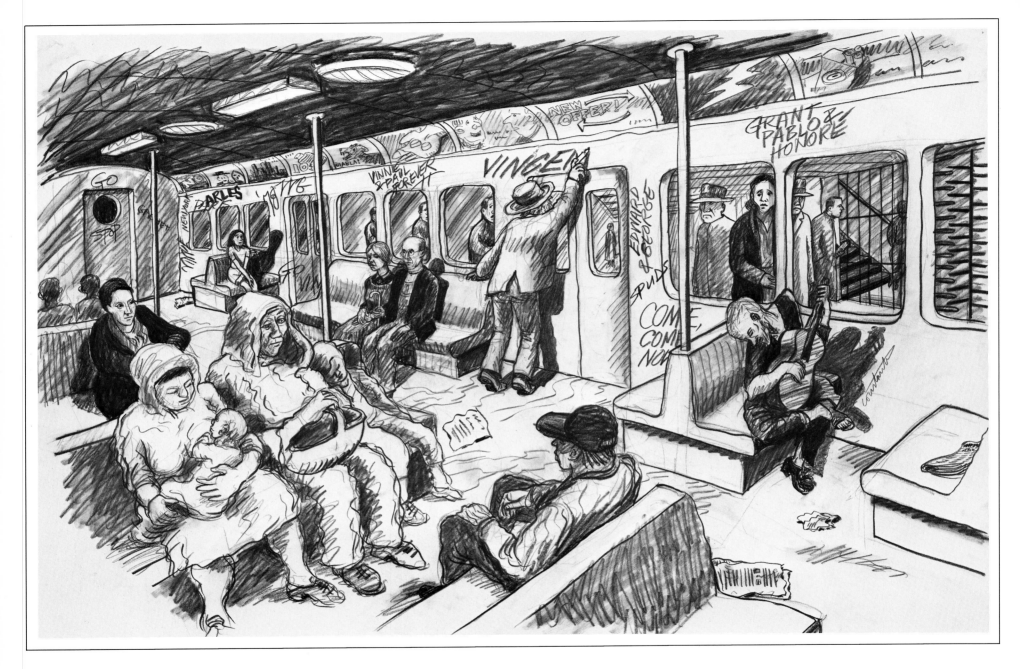

Riding the third-class subway

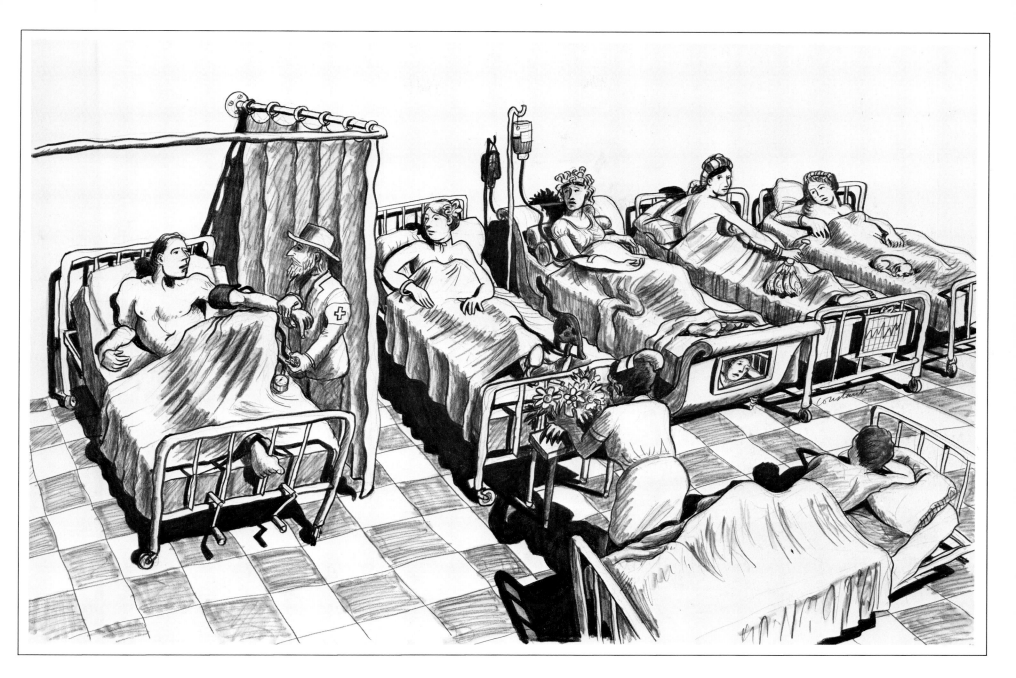

Checking Adam's blood pressure in St. Vincent Hospital's Art Clinic

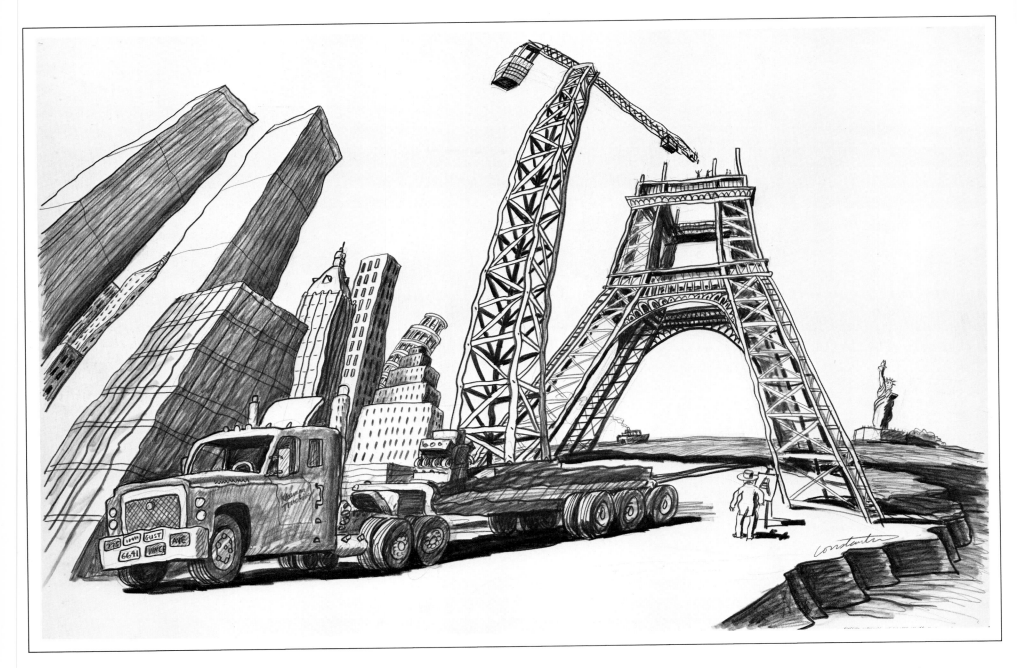

Watching the disassembling of Eiffel's Tower in Battery Park before it's sent to Paris as a gift

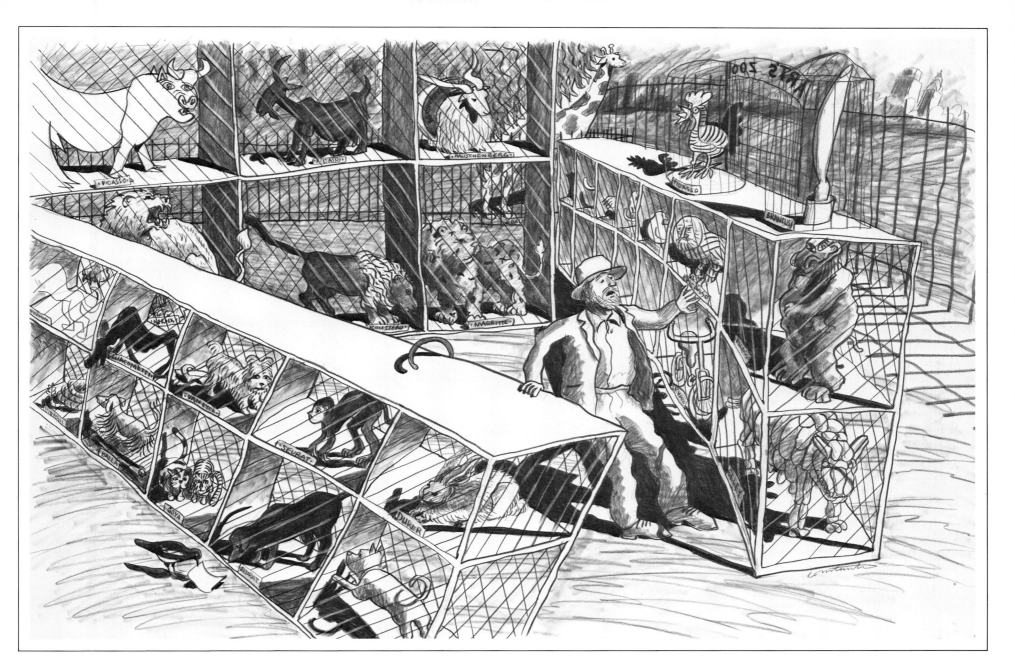

Visiting Central Park's Art Zoo

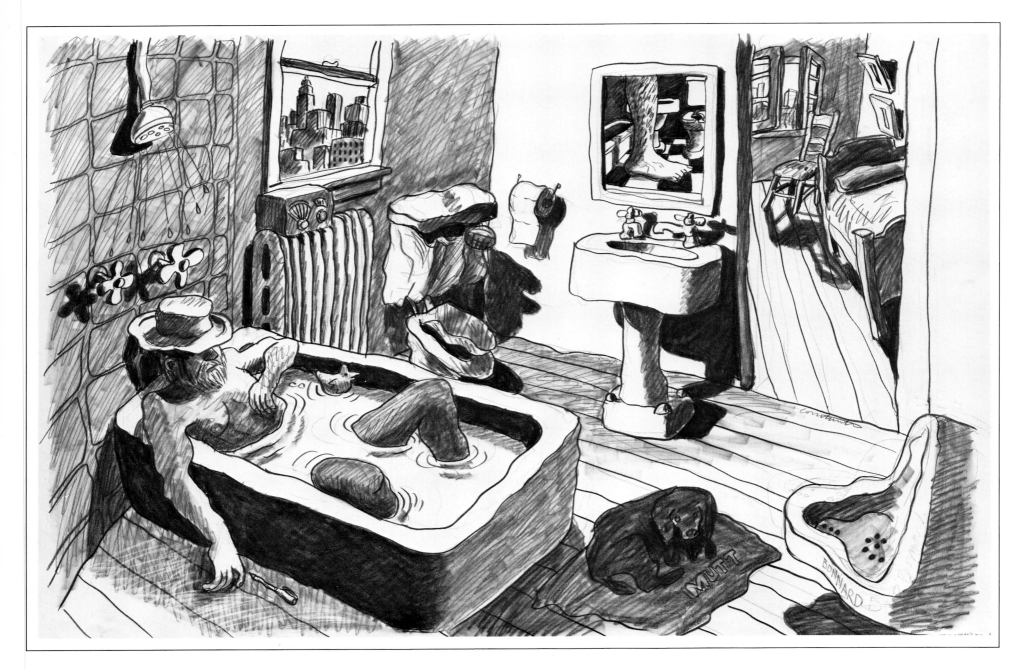

Bathing in Marat's tub

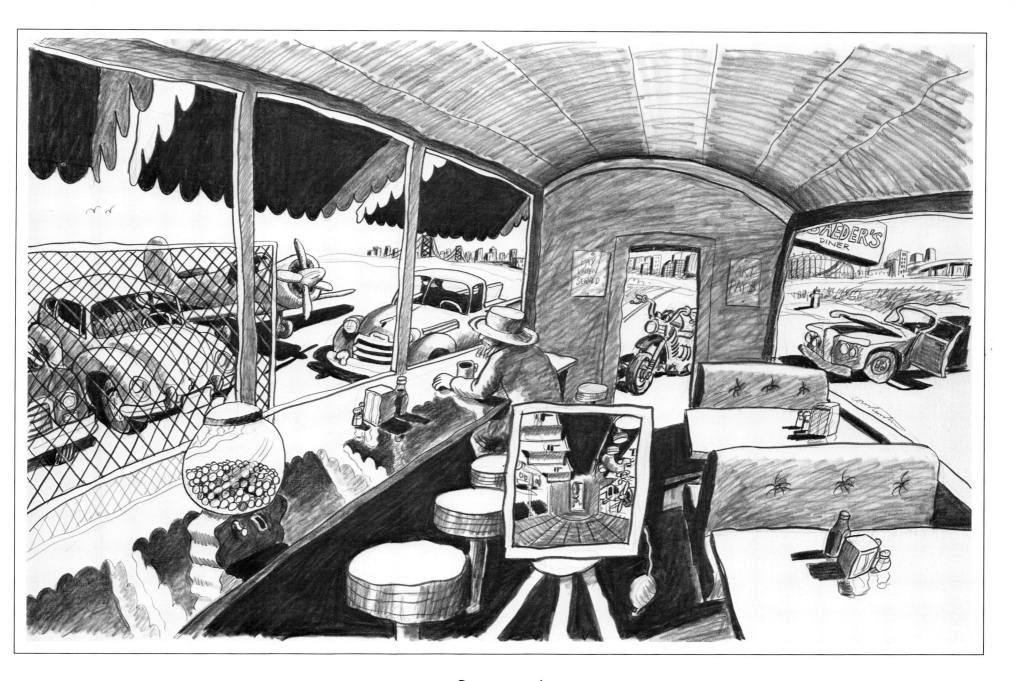

Dining out

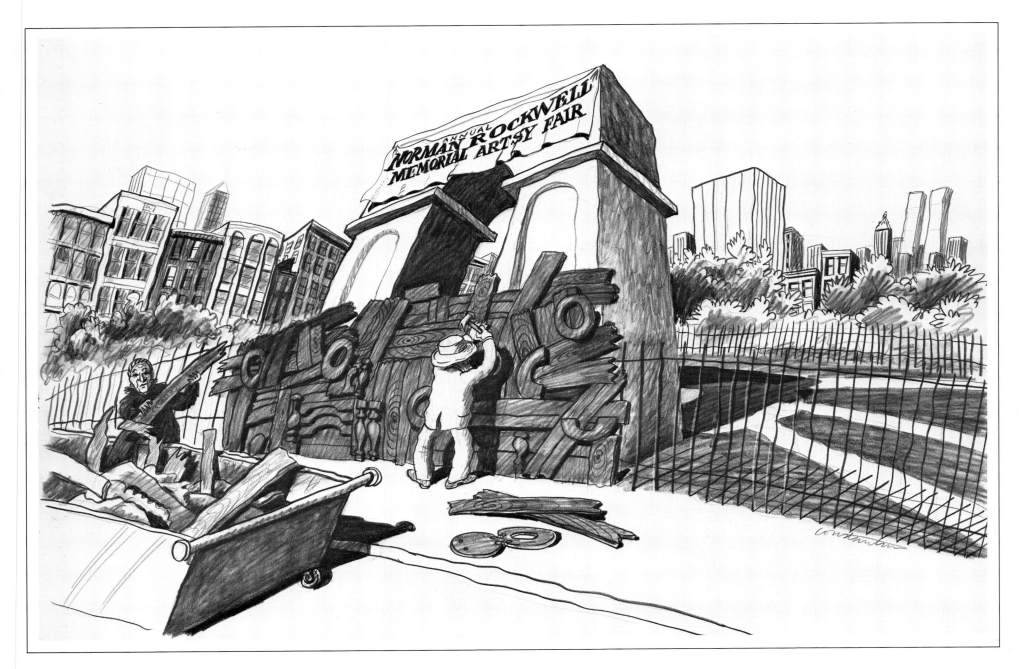

Protesting the Washington Square Art Fair

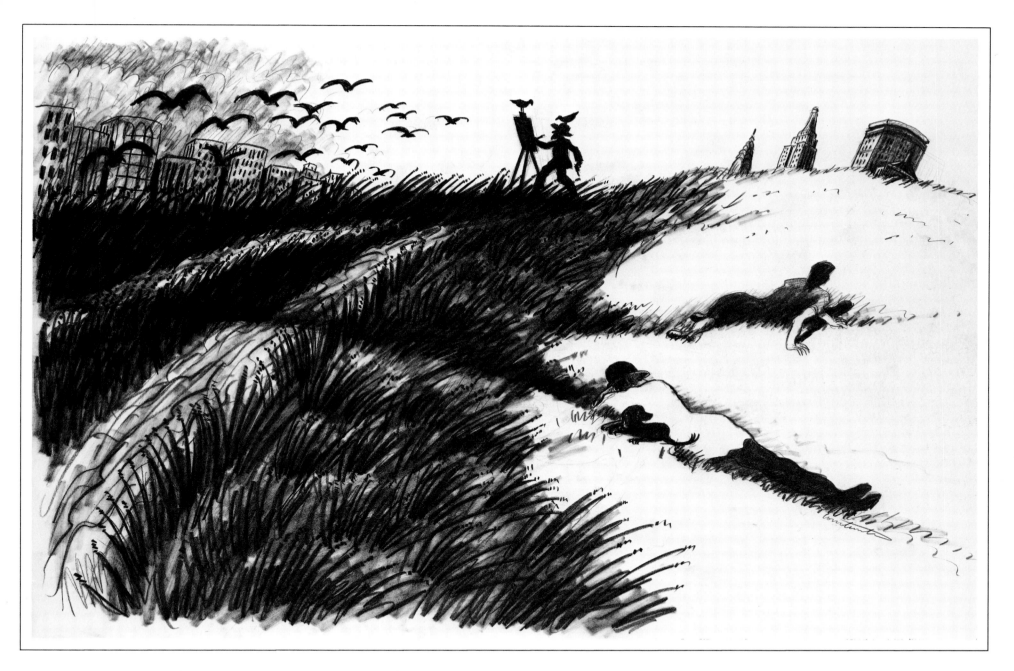

Painting pigeons over Central Park

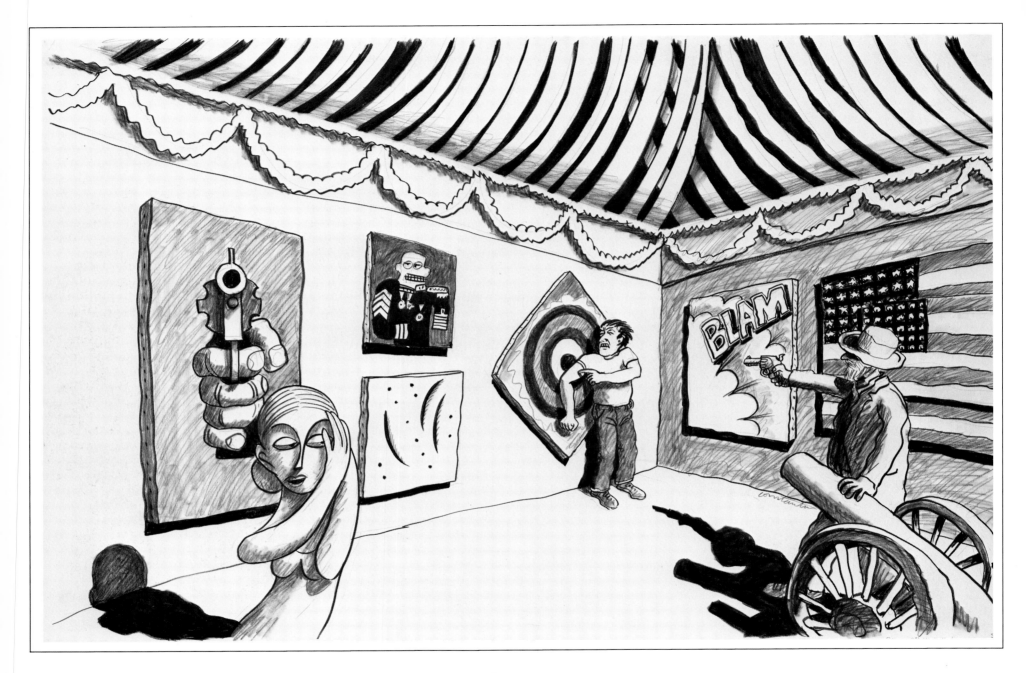

1983 Armory Show

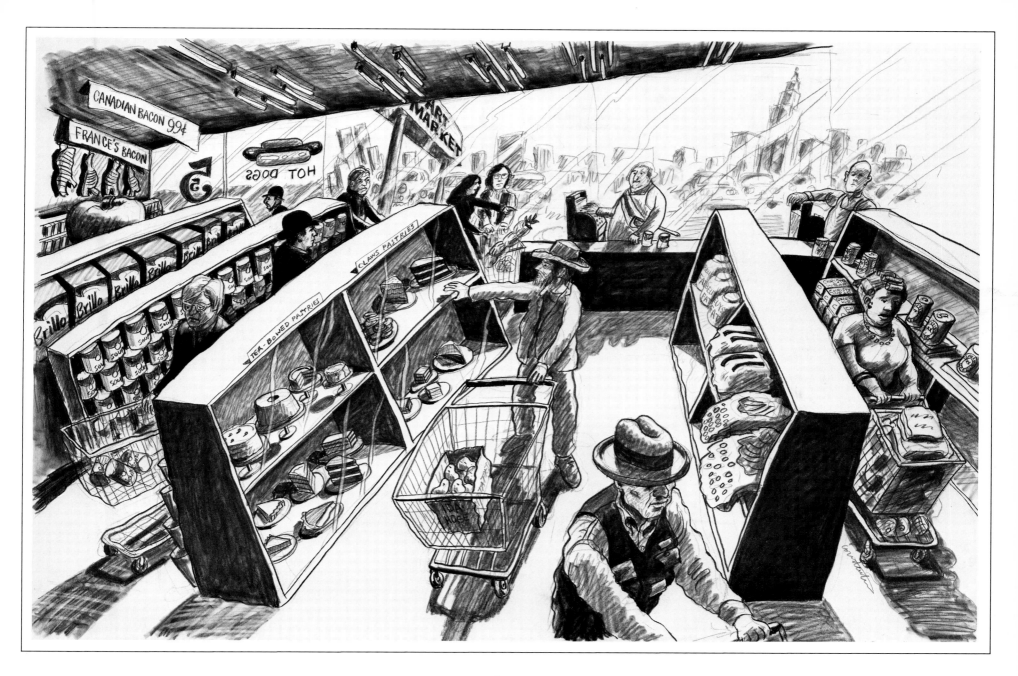

Shopping in the Art Market

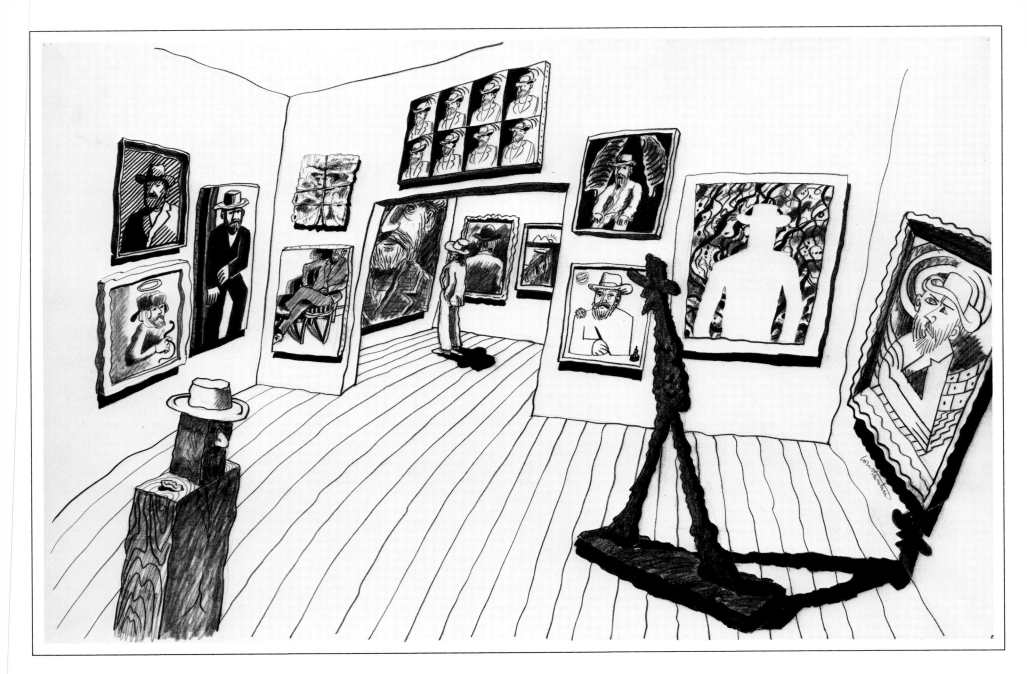

Attending an "Homage to Van Gogh" exhibit at M.O.M.A.

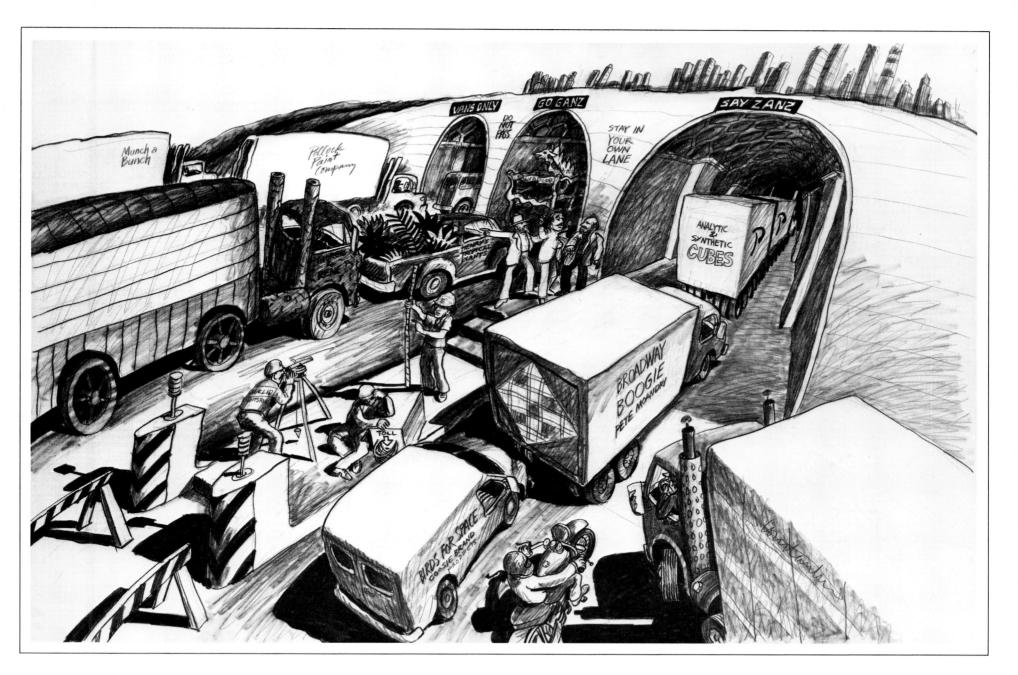

School of Holland Tunnel

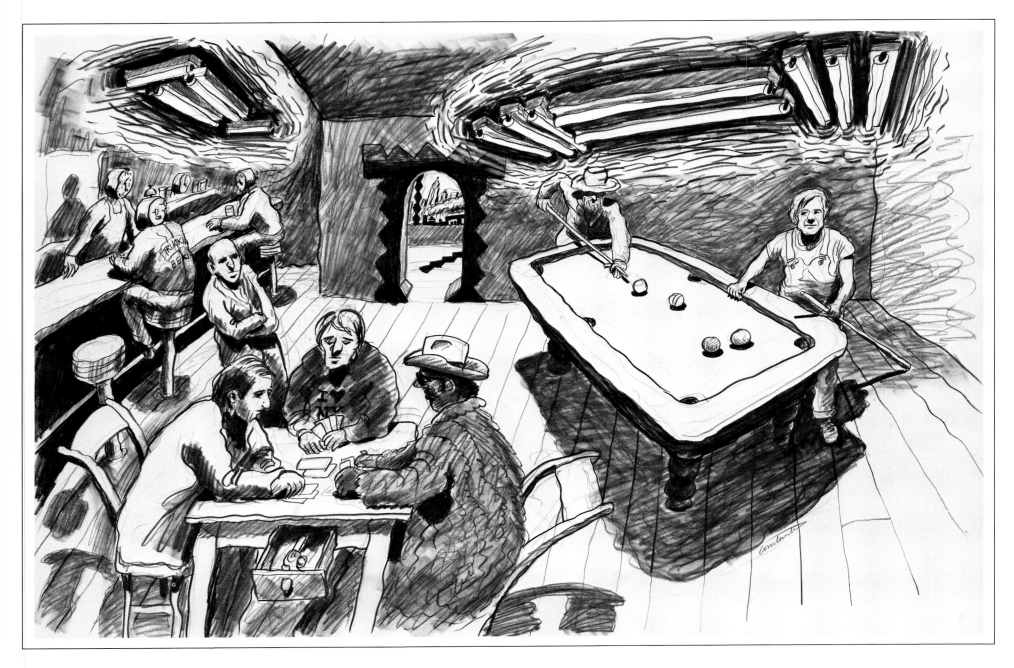

Playing pool with de Kooning at the Cedar Bar

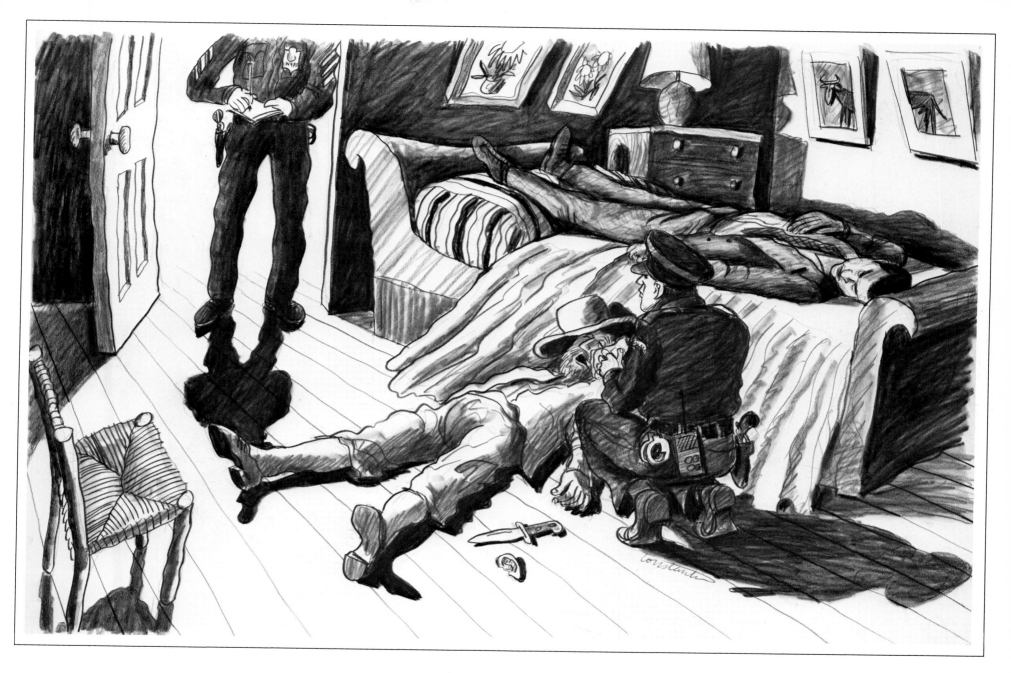

Losing an ear at Hotel Transnonian

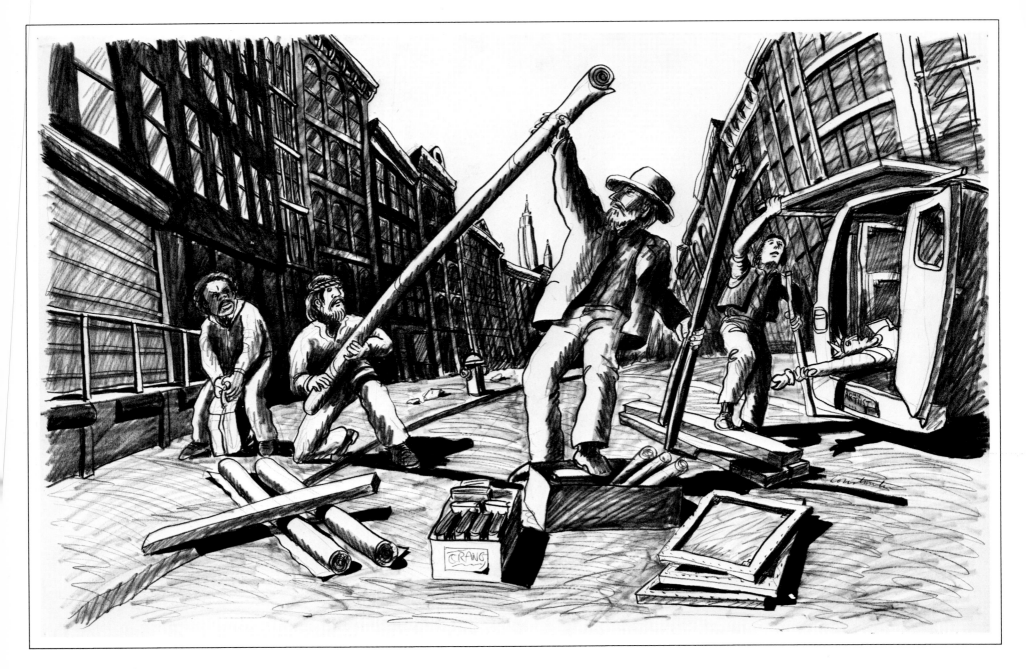

Loading the van

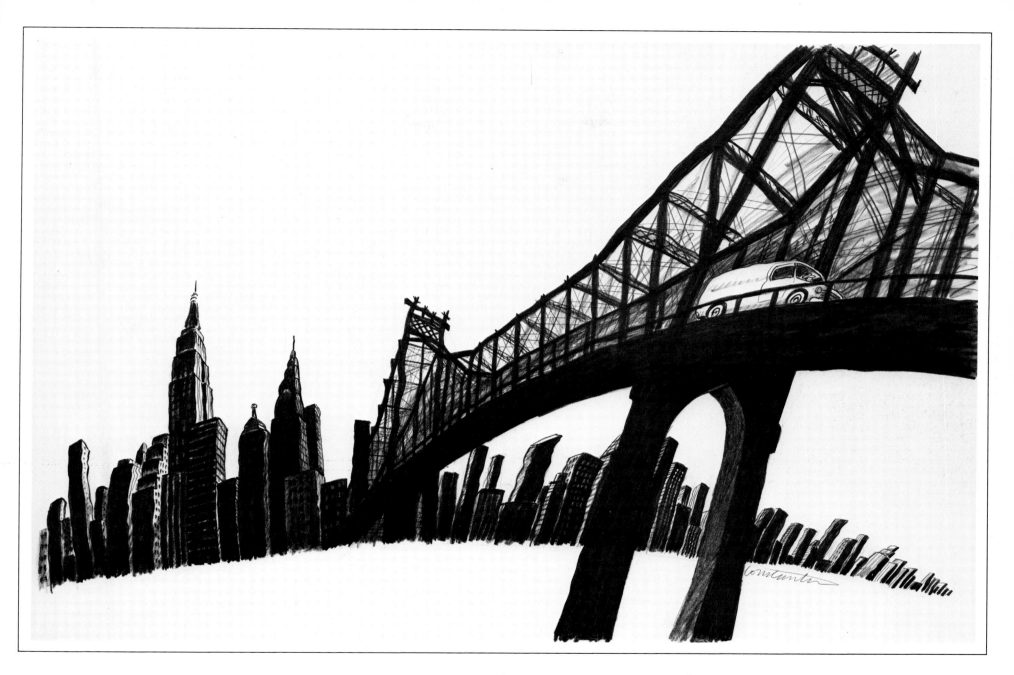

Vincent and his van going to Long Island after "Making It" in New York

This compilation is intended to list the artworks quoted in the drawings, as well as the artists who are pictured, and other references to artworks or artists.
***artist other than Vincent is pictured**
+direct or indirect reference to the artist or his work

Page

References to Artworks

Demuth, *I Saw the Figure Five in Gold*
Indiana, *Figure 5*
Oldenburg, *Typewriter Eraser*
*Oldenburg
+Albers, Beuys, Christo, Dali, Flavin, Gainsborough, Matisse, Mondrian, Nevelson, Oldenburg, Picasso, Pollock, Rembrandt, Renoir, Segal, Stella, Toulouse-Lautrec, Whistler

37 **Strolling on the Brooklyn Bridge with Joe and Frank Stella**
Munch, *Girls on the Bridge*
Stella, F., *Ctesiphon III*
Stella, J., *Brooklyn Bridge*
*Stella, F., Stella, J.
+Marin, O'Keefe

38 **Using Chuck Close's studio to paint a self-portrait**
Oldenburg, *Colossal Ear*
Van Gogh, *Self-Portrait*
+Close

39 **Painting Warhol daisies in the Guggenheim**
Warhol, *Daisies*
*Nevelson

40 **Dali attempting to melt the Flatiron Building**
Dali, *The Burning Giraffe*
Duchamp, *Chocolate Grinder*
Magritte, *La Découverte du Feu*
*Dali
+Flatiron building

41 **Quelling the conflict between the Realists and Abstractionists**
Daumier, *The Battle of the Schools*
David, *The Sabine Women*
*Pollock, Rockwell

42 **Vincent visiting Kienholz's Car at the Whitney**
Constantine, *Artist Licenses*
Kienholz, *Back Seat Dodge 38*
Rauschenberg, *Monogram*
Seley, *Car Bumper*
*Chamberlain, Rauschenberg, Seley

43 **Unwrapping the Statue of Liberty**
Christo, *Portrait du B. B. empaqueté*

44 **Van Gogh going at Studio 54**
Matisse, *The Dance*

45 **Painting a series of St. Patrick's Cathedrals**
Monet, *Rouen Cathedral: Tour d'Albane, Early Morning*

46 **Planting tulips in De Maria's Earth Room**
De Maria, *Earth Room*
Millet, *The Angelus*
Van Gogh, *The Sower*

47 **At the bar during his opening reception**
Manet, *The Bar at the Folies-Bergère*
Van Gogh, *The Postman Roulin*
Van Gogh, *Self-Portrait*
Van Gogh, *Starry Night*
Van Gogh, *Sunflowers*
*Albers, de Kooning, Gottlieb, Guston, Hoffmann, Jenkins, Kline, Motherwell, Nevelson, Newman, Pollock, Rivers, Rothko, Still, Toulouse-Lautrec

48 **Vincent in Washington Albers' Square**
Albers, *Homage to the Square: "Ascending"*
Brancusi, *Endless Column*
Brancusi, *Gate of the Kiss*
Oldenburg, *Clothespin*

49 **Getting plastered at George Segal's Diner**
Oppenheim, *Fur-lined Teacup*
Segal, *The Diner*

50 **Throwing Dali out of his loft**
Halsman, *Dali Atomicus*
Van Gogh, *The Night Café*
Van Gogh, *Sunflowers*
*Dali
+Pearson

51 **Joining the "Irascibles"**
Leen, *Painters of the New York School, 1951*
*(left to right: Pousette-Dart, Stamos, Baziotes, de Kooning, Ernst, Gottlieb, Newman, Pollock, Reinhardt, Brooks, Sterne, Still, Rothko, Motherwell, Tomlin)

52 **Pollock painting Vincent's portrait**
Pollock *Convergence*
Van Gogh, *The Night Café*
*Pollock

53 **Serving Pope Picasso on West Broadway**
Capa, *Picasso, Françoise Gilot, and Fin Vilato*
*Picasso

54 **Contemplating Oldenburg's Colossal Ear**
Oldenburg, *Colossal Ear*

55 **Painting a portrait of his mother**
Beckmann, *Self-Portrait*
Gauguin, *The Vision After the Sermon—Jacob Wrestling with the Angel*
Gottlieb, *Bowery Burst*
Johns, *Painted Bronze*
Leonardo, *Mona Lisa*
Magritte, *The Treachery (or Perfidy of Images)*
Manet, *Olympia*
Matisse, *The Green Line (Madame Matisse)*
Matisse, *The Red Studio*

Mondrian, *Composition with Yellow*
Picasso, *Ceramic fish plate*
Van Gogh, *The Night Café*
Whistler, *Arrangement in Gray and Black ("Whistler's Mother")*

56 **Attending an exhibit of self-portraits at the Metropolitan**
Van Gogh, *Self-Portrait*

57 **Seeing Kirk Douglas at the premiere of *Lust for Life***
Cottingham, *Art*
Segal, *The Movie House*
+Michelangelo, Toulouse-Lautrec, Hairy Who

58 **Riding the third-class subway**
Daumier, *The Third Class Carriage*
Munch, *Puberty*
Picasso, *Gertrude Stein*
Picasso, *The Old Guitarist*
Tooker, *The Subway*
Wood, *American Gothic*
+Haring

59 **Checking Adam's blood pressure in St. Vincent Hospital's Art Clinic**
David, *Madame Récamier*
Ingres, *La Grande Odalisque (Odalisque Couchée)*
Michelangelo, *Creation of Man*
Manet, *Olympia*
Titian, *Venus of Urbino*
Velasquez, *Venus and Cupid*

60 **Watching the disassembling of Eiffel's Tower in Battery Park before it's sent to Paris as a gift**
+Eiffel Tower, Leaning Tower of Pisa

61 **Visiting Central Park's Art Zoo**
Balla, *Dynamism of a Dog on a Leash (Leash in Motion)*
Brancusi, *Bird in Space*
Dali, *The Burning Giraffe*
Delacroix, *Lion Hunt*
Dürer, *Hare*
Giacometti, *Dog*
Goya, *Don Manuel Osorio de Zuñiga*
Magritte, *Lion*
Picasso, *Baboon and Young*
Picasso, *Bull's Head*
Picasso, *Cock*
Picasso, *Dove*
Picasso, *The Goat*
Picasso, *Owl with the Head of a Woman*
Picasso, *Minotaur*

Rauschenberg, *Monogram*
Rousseau, *The Sleeping Gypsy*
Seley, *Lupa Capitolina II*
Seurat, *A Sunday Afternoon on the Island of la Grande Jatte*
Van Eyck, *Giovanni Arnolfini and His Bride
(Giovanna Cenami)*

62 **Bathing in Marat's tub**
Bonnard, *Nude in Bathtub*
David, *The Death of Marat*
Dine, *Shower*
Duchamp, *Fountain*
Michals, *Things Are Queer*
Oldenburg, *Soft Toilet*
Van Gogh, *The Artist's Bedroom at Arles*
Wesselmann, *Great American Nude No. 48*

63 **Dining out**
Baeder, *Diner, Newark, N.J.*
Bell, *Gum Ball No. 3, 1973*
Blackwell, *Bleecker Street Bike*
Eddy, *Private Parking X*
Goings, *Dick's Union General*
Goings, *Still Life—Untitled Ketchup*
Kleemann, *Leo's Revenge*
Salt, *Pioneer Pontiac*

64 **Protesting the Washington Square Art Fair**
Nevelson, *Royal Tide*
*Nevelson
+Rockwell

65 **Painting pigeons over Central Park**
Seurat, *La Baignade*
Van Gogh, *Crows Over the Wheat Field*
Wyeth, *Christina's World*

66 **1983 Armory Show**
Baj, *L'abbé d'Olivet*
Brancusi, *Mlle. Pogany*
Fontana, *Spatial Concept*
Johns, *Flag*
Kandinsky, *Improvisation No. 30 (cannon)*
Lichtenstein, *Blam*
Lichtenstein, *Pistol*
Noland, *Mercer*

67 **Shopping in the Art Market**
Bacon, *Head Surrounded by Sides of Beef*
Demuth, *I Saw the Figure Five in Gold*
Flavin, *Untitled*
Goya, *The Family of Charles IV*
Hanson, *Supermarket Lady*
Indiana, *Figure 5*

Johns, *Painted Bronze*
Lichtenstein, *Hot Dot*
Magritte, *Chambre d'écoute*
Oldenburg, *Soft Toaster "Ghost" Version*
Oldenburg, *Soft Typewriter "Ghost" Version*
Oldenburg, *Floor-Cake*
Oldenburg, *Pastry Case, I*
Thiebaud, *Cakes*
Van Gogh, *The Potato Eaters*
Warhol, *Brillo Boxes*
Warhol, *One Hundred Campbell's Soup Cans*
*Bacon, Beuys, Christo, Magritte, Oldenburg,
Toulouse-Lautrec, Warhol
+Beuys, Christo

68 **Attending an "Homage to Van Gogh" exhibit
at M.O.M.A.**
+Bacon, Beckmann, Christo, Close, Dali, Gauguin, Giacometti,
Hanson, Lichtenstein, Magritte, Marisol, Picasso, Pearlstein,
Pollock, Steinberg, Warhol

69 **School of Holland Tunnel**
Dali, *The Burning Giraffe*
de Chirico, *Melancholy and Mystery of a Street*
Magritte, *Legend of the Centuries*
Mondrian, *Victory Boogie-Woogie*
Raphael, *The School of Athens*
Rousseau, *The Dream*
*Cézanne, Gauguin, Michelangelo
+Brancusi, Dali, de Chirico, Magritte, Mondrian, Munch,
Picasso, Pollock

70 **Playing pool with de Kooning at the Cedar Bar**
Brancusi, *Endless Column*
Brancusi, *Portal*
Cézanne, *The Cardplayers*
de Chirico, *The Soothsayer's Recompense*
Flavin, *Untitled*
Kienholz, *The Beanery*
Van Gogh, *The Night Café*
*de Kooning

71 **Losing an ear at Hotel Transnonian**
Daumier, *Rue Transnonian, le 15 avril*
Manet, *The Dead Toreador*
Picasso, *Bull*
Van Gogh, *Bedroom at Arles*
Van Gogh, *Sunflowers*
Van Gogh, *The Yellow Chair*

72 **Loading the van**
Delacroix, *Liberty Leading the People*

73 **Vincent and his van going to Long Island after
"Making It" in New York**

A Note About the Author

Greg Constantine was born in Windsor, Ontario, Canada, in 1938, of parents born in Romania. He has taught painting and art history at Andrews University in Michigan for twenty years, while at the same time exhibiting his paintings in Canada, Romania, and all over the United States including two one-man shows in Chicago and four in New York City. During the last seven years, his subject matter has dealt with recycling famous artists' imagery including, most recently, artist licenses, which are realistic looking license plates designed as if the artist had had the opportunity to incorporate his own signature and imagery—for example, Christo's plate is wrapped, Dali's is melting and Nevelson's is all black. He is represented by the O.K. Harris Gallery in New York City. His frequent trips to New York City and an appreciation of Vincent's innocent nature inspired this book.